BFI Film Classics: A brief history

The BFI Film Classics series grew out of a project initiated by the National Film and Television Archive (NFTVA), a division of the BFI, to build a collection of 'perfect showprints' of 360 key films in the history of cinema. These films were to be screened at the Museum of the Moving Image (MOMI) in London in a year-round repertory. The '360 list' of classic films was drawn up by David Meeker of the NFTVA, and the BFI Film Classics books were commissioned to stand alongside the Archive project.

Distinguished film critics and scholars, film-makers, novelists and poets, historians and writers from other spheres of the arts and academia were approached to write on a film of their choice from the '360 list'. Each volume was 'to present the author's own insights into the chosen film, together with a brief production history and detailed credits, notes and bibliography.' In a time before DVDs and screengrabs, the books' 'numerous illustrations' were specially made from the Archive's own prints and sourced from the BFI's stills' collection.

The series was developed and its first titles commissioned by Edward Buscombe, then Head of Publishing at the BFI. Colin MacCabe and David Meeker acted as series consultants. Rob White was the Series Editor at the BFI from 1996 to 2005.

The series was launched in May 1992 with four titles: *The Wizard of Oz* by Salman Rushdie; *Double Indemnity* by Richard Schickel; *Stagecoach* by Edward Buscombe and *Went the Day Well?* by Penelope Houston.

A sister series, BFI Modern Classics, was launched in 1996 to respond to notable films of modern and contemporary cinema. Over 60 titles were published in this series before it was absorbed within the main Film Classics series in 2007, and the combined series was relaunched with a new cover and text design. There are currently over 160 titles in print in the Film Classics, Modern Classics and combined Film Classics series.

A BFI Film Classics series advisory board, comprising representatives from the BFI, as well as leading film scholars and critics, was established in 2007. Since 2008 Film Classics series, have been published ip with the BFI.

D1292927

Snow White and the Seven Dwarfs

Eric Smoodin

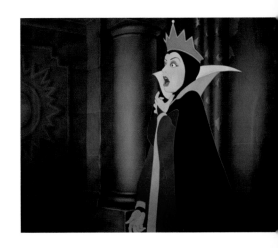

palgrave
macmillan

A BFI book published by Palgrave Macmillan

For Sofia

First published in 2012 by
PALGRAVE MACMILLAN

on behalf of the

BRITISH FILM INSTITUTE
21 Stephen Street, London W1T 1LN
www.bfi.org.uk

There's more to discover about film and television through the BFI. Our world-renowned archive, cinemas, festivals, films, publications and learning resources are here to inspire you.

Palgrave Macmillan in the UK is an imprint of Macmillan Publishers Limited, registered in England, company number 785998, of Houndmills, Basingstoke, Hampshire RG21 6XS. Palgrave Macmillan in the US is a division of St Martin's Press LLC, 175 Fifth Avenue, New York, NY 10010. Palgrave Macmillan is the global academic imprint of the above companies and has companies and representatives throughout the world. Palgrave® and Macmillan® are registered trademarks in the United States, the United Kingdom, Europe and other countries.

Front cover design: Su Blackwell; photography: Jochen Braun
Series text design: ketchup/SE14
Images from *Snow White and the Seven Dwarfs*, © Walt Disney Productions; *Alice's Wonderland*, Laugh-O-Gram Films; *Steamboat Willie*, Walt Disney Productions/Celebrity Productions; *The Three Caballeros*, © Walt Disney Productions; *Snow White* (1916), Famous Players-Lasky Corporation; *Snow White* (1933), © Paramount Production, Inc.; *Flowers and Trees*, © Walt Disney Productions; *The Old Mill*, Walt Disney Productions; *The Toll of the Sea*, Technicolor Motion Picture Corporation; *The Three Little Pigs*, © Walt Disney Productions; *Coal Black and de Sebben Dwarfs*, Vitaphone Corporation/Warner Bros.; *Seven Wise Dwarfs*, © Walt Disney Productions; *The Winged Scourge*, © Walt Disney Productions; *Enchanted*, © Disney Enterprises, Inc.

Set by Cambrian Typesetters, Camberley, Surrey
Printed in China

This book is printed on paper suitable for recycling and made from fully managed and sustained forest sources. Logging, pulping and manufacturing processes are expected to conform to the environmental regulations of the country of origin.

British Library Cataloguing-in-Publication Data
A catalogue record for this book is available from the British Library
A catalog record for this book is available from the Library of Congress
10 9 8 7 6 5 4 3 2 1
21 20 19 18 17 16 15 14 13 12

ISBN 978–1–84457–475–9

Contents

Preface

My mother graduated from Tuley High School in Chicago in 1938. The student population at Tuley was largely Jewish, and made up of many first-generation Americans, the children of émigrés from Eastern Europe. I still have her graduation yearbook. It includes photos of all the classes, teams and clubs, and on the page opposite the picture of the French Club, of which my mother was a member, there is a portrait of the Clean-Up Committee, and just below that, the cast of the Clean-Up play. In the front row are six boys with long, fake white beards, one boy with oversized rubber ears and a teenage girl in a princess costume. Behind them are the rest of the cast and crew. The caption tells us that 'among the Clean-Up Committee's glorious triumphs was the hilarious play *Snow White and the Seven Cleanies*', produced in April 1938.[1]

Disney's animated feature *Snow White and the Seven Dwarfs* had opened in Chicago just one month earlier, in March, but well before then, and before its grand premiere in Los Angeles in December 1937, the film had become something of a national

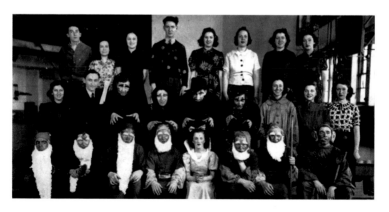

The cast and crew of *Snow White and the Seven Cleanies*, the Tuley High School performance from 1938

sensation. One can well imagine that most of the teenagers at Tuley High had seen the film by the time of the Clean-Up play, and that they were also ready to make some gentle fun of it, as the theatrical almost certainly did. The students' use of Disney's film probably signified both their pleasure in the movie and their adult distance from some of the childhood delights of animation, as well as their place as fully formed American cultural consumers.

At about the same time, in May 1938, and also in Chicago, the author Thomas Wolfe went for a night on the town with some faculty members and students from Purdue University in Indiana. On the extended drive from the college to the city, everyone in the car sang popular songs, and Wolfe enthusiastically took part. One of the party remembered that 'the song that delighted him most was the dwarfs' "Heigh-Ho" song from *Snow White and the Seven Dwarfs*'. Wolfe, in fact, sang it constantly, 'even walking across a quiet street in Chicago ... with a ludicrously serious look on his face'. As that participant politely put it, but sounding very much like a host whose initial excitement at being in the presence of the famous author has dwindled to boredom, 'and he kept singing it after some of its original charm had worn off'.[2]

One other random anecdote about the film, from a very different place, illustrates the sweep of its appeal. When the movie opened in France, a fan in Paris sent a letter to the country's most prominent film magazine, *Pour Vous*, to acknowledge Disney's great work, and to elevate it beyond the realm of the mere cartoon. 'Not only does the film make its mark in the history of animation,' she wrote, 'but also, quite simply, in the history of cinema.' She continued, 'This is a masterpiece that one must see many times ... so as not to miss a single detail.'[3]

Thus, we have a film that, within months of its release, had taken on international importance. It acted as a touchstone in different communities across the United States, and was almost certainly referenced and spoofed by schoolchildren throughout the country (students at the Evander Childs High School in New York

produced a play in 1938 or 1939 that sounded just a little grimmer than the one staged at Tuley High: *Snow White and the Seven Propaganda Devices*).[4] The film also made its way into highbrow American letters; as we will see, in literary circles it was not just the famously boozy Wolfe who delighted in *Snow White*. And outside of the United States, just as it did for that viewer in Paris, *Snow White* was greeted as a staggering cultural achievement.

For his first feature-length animated film, Walt Disney had produced an instant classic, and had fulfilled the vast and varied expectations of a global audience.

1 Pre-History

Developing a reputation: Disney before *Snow White*

On 27 December 1937, a week after *Snow White and the Seven Dwarfs* premiered in Los Angeles, Walt Disney appeared on the cover of *Time* magazine.[5] The film-maker shared space in the photograph with some of his newest stars, and received billing at the bottom: 'Happy, Grumpy, Bashful, Sneezy, Sleepy, Doc, Dopey, Disney'. But the cover nevertheless elevated the studio head to a special status among American artists, as the equal of perhaps the nation's greatest painter. The caption stated succinctly, 'The boss is no more a cartoonist than Whistler,' thus imagining a straight line from the iconic *Whistler's Mother* to Disney's latest princess, and letting readers know that *Snow White* marked a significant moment in American art and culture.

Time's readers may have anticipated this moment and Disney's new film, his first animated feature, for a number of years. Having entered the business in the early 1920s, Walt Disney had been famous for almost a decade, but by the early 1930s he had emerged as a special kind of American hero, the ideal combination of entrepreneur and artist. For Americans interested in culture, as well as for those just enthusiastic about movies, *Snow White* seemed the culmination of years of work, and a filmgoing experience unlike any other. Viewers understood the film to be a work of art, a great entertainment and ideal for all ages, a combination perhaps only achieved before by some of the films of Charlie Chaplin.

Disney's esteemed reputation in 1937 was in marked contrast to the earliest references to him in the press and to his first cartoon heroine. In 1924, the *Los Angeles Times* allotted only a few lines of space on a back page to a brief mention of 'a young cartoonist by the name of Walt Disney' who was 'making a series of twelve

animated cartoon productions' about a girl named Alice.[6]
These were Disney's *Alice in Cartoonland* films that mixed live
action with animation, and that drew, of course, on Lewis Carroll's
nineteenth-century fairy tale, just as, later, Disney would adapt the
fairy-tale sources – the Brothers Grimm most prominently – for
Snow White.

After Alice, Disney's fame and reputation increased
dramatically, of course, with the introduction of Mickey Mouse.
His studio's early and complete commitment to the new sound
technology of the late 1920s, and Disney's determination in this early
period to make music a fundamental aspect of all of his cartoons,
made critics and the public take notice. Industrial imperatives also
helped, as the unceasing demand from the country's 20,000 or so
cinemas for product – from features to live-action shorts to newsreels
to cartoons – provided a speciality studio like Disney with steady
outlets for its animated short subjects.

Walt Disney shows Alice a drawing that has come to life, in *Alice's Wonderland*, from
1923

Disney's rise began, tentatively enough, with *Steamboat Willie*, the second Mickey Mouse cartoon, but also the film that signalled the studio's conversion to sound. When the film premiered in New York in 1928, paired with a now forgotten feature film called *Gang War*, the critic for *The New York Times* noted it as 'the first sound cartoon', and identified the producer, quite formally, as 'Walter Disney', reminding readers that he had become known for a previous series of animated shorts starring Oswald the Rabbit.[7] Just one year later, Disney was admired as both innovator and artist, at the forefront of mixing sound with image. When his newest *Silly Symphony* cartoon, *Springtime*, played at the lavish Grauman's Chinese Theater in Hollywood (appearing just after the widely acclaimed *Skeleton Dance*), the *Los Angeles Times* proclaimed that 'Imagination in picture-making has at no time been

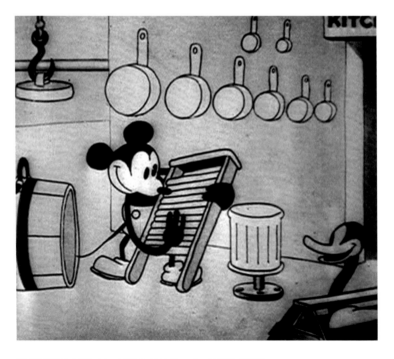

Mickey Mouse plays a washboard in *Steamboat Willie* (1928)

more strikingly disclosed than in the Walt Disney comic currently' showing.[8] In the months to follow, the fame of the producer and an assumption about the quality of his product became universally accepted. In April 1931, to cite just one example among many, the leading French film magazine *Pour Vous* acknowledged Disney's greatness and then lamented France's own apparent lack of an animated film industry, asking, 'Will we have our own ... Mickey any time soon?'[9]

At the time of this developing reputation, Disney produced cartoons with assembly-line regularity: 19 animated shorts in 1930, 22 in 1931 and 1932, then another 19 in 1933. These films were distributed to exhibitors in two series, the *Silly Symphonies* and the *Mickey Mouse* cartoons, in fairly even numbers. Disney more or less maintained these production schedules even as his studio shifted much of its emphasis to feature films in the mid- to late 1930s. In 1937, the year the studio completed *Snow White*, Disney produced fourteen cartoon shorts, made up of the *Mickey Mouse* films, one *Donald Duck* (*Donald's Ostrich*) and the *Silly Symphonies*. It was the films of this latter series that most anticipated *Snow White*. Like all Disney films of the time, the *Symphonies* were made in Technicolor and emphasised sophisticated musical scores, while many of them, for instance the much-heralded *The Old Mill* (1937), sought to establish mood and tone as well as narrative, much in the manner of *Snow White*.

Interestingly enough, this regular supply of product and the early adoption of sound, as much as the subject matter of the films, helped make Disney an icon of modernity in the eyes of the emerging American avant-gardes in the 1920s and 30s. The various experimental art groups, from the editors of the short-lived literary magazine *The Soil* (1916–18) to the more acclaimed Dadaists, celebrated the apparent challenges to high art posed not only by photographers such as Paul Strand and such 'Ashcan' painters as George Bellows, but also by Disney and Mickey Mouse. They extolled the highly technologised production of so much

popular culture, and especially the labour-intensive, mechanised animated films of the period.[10] The *Silly Symphonies* in particular, however, delivered middlebrow refinement rather than avant-garde pleasures to film audiences, and critics, intellectuals and various reform groups, so rarely speaking with one voice at the time, praised them as perfect entertainment for all viewers.

This endorsement of Disney's universal appeal situated the cartoon producer on the 'correct' side of significant debates about cinema that took place during the 1930s. As a means of dealing with protests from parents' and teachers' organisations, religious groups and others mobilising against movies, the major studios had begun to assert more fully the literary and historical worthiness of their product; hence the production of films such as *Little Women* (RKO, 1933), *The Barretts of Wimpole Street* (MGM, 1934), *Romeo and Juliet* (MGM, 1936) and *The Story of Louis Pasteur* (Warner Bros., 1938). While film historians have written for at least the last decade about this attempt to prove the high-mindedness of American cinema, one of the more little-known conflicts of the period concerned the perception of a demographic divide in movie tastes. In particular, residents in small towns often felt that Hollywood made films for big cities such as New York, Los Angeles and Chicago, with a sensibility geared towards more urban audiences. Walt Disney, along with Frank Capra and a few other film-makers, was among a very small group of men who were considered capable of providing films that might be considered both cosmopolitan and rural. At the same time, even though Hollywood assumed that all audiences should be able to see and enjoy all films, many viewers and critics recognised that the studios produced movies for very specific age groups and made very few films for the entire family. Thus, all of the *Mickey Mouse* films and *Silly Symphonies* set a precedent and established the formula for a movie like *Snow White*, which would emerge as something of a perfect Hollywood product: one that demonstrated the movie industry's commitment to a kind of literary high quality, and as a film that could be enjoyed by sophisticated and

also less worldly audiences, by children as well as adults, by city audiences and those in small towns.

Throughout the period of Disney's ascendance, Hollywood's production, marketing and exhibition methods received ample criticism from parents' and teachers' groups, psychologists, intellectuals and others. In 1939, sociologist Margaret Farrand Thorp, in one of the founding volumes of modern film studies, *America at the Movies*, went so far as to claim that viewers lacked all agency and free will even when it came to deciding which movie to see on a given night. Farrand was a film enthusiast and defender of popular culture, but she wrote ominously that the choice of film 'was predestined months ago, predestined by forces working so steadily and so subtly that the chooser is usually quite unaware how he got it fixed in his mind that *The Life of Mr Blank* is a film he really ought to see'.[11] But at least during the 1930s, critics placed Disney and very few other film-makers in a different category from other members of the studio system, and well beyond the ceaseless cookie-cutter of the studio assembly line. As Thorp also wrote, 'The pearl of great price' in the film industry 'is the picture that pleases everybody', adding that 'So far, just two pearls have been found: Charlie Chaplin and Walt Disney.' Commenting on Disney's most recent film and his most famous character, she claimed that 'On *Snow White* and Mickey Mouse it is scarcely possible to find a dissenting' critical voice.[12]

The comparisons to Chaplin had been commonplace for years. As early as January 1933, just five years after Mickey Mouse's debut but almost two decades after the Little Tramp's, the *Survey Graphic* magazine examined 'recent trends in the arts'.[13] The *Graphic* was one of the significant middle- to highbrow publications of the period, commenting with authority on issues of political and cultural importance (in 1925, for instance, it famously coined the term 'New Negro' in its special issue on Harlem). Discussing the art scene in 1933, the magazine wondered about the impact of 'mass production and modern distribution', while celebrating advances in interior design by William Lescaze, furniture by Silvia Van Rensselaer, the new

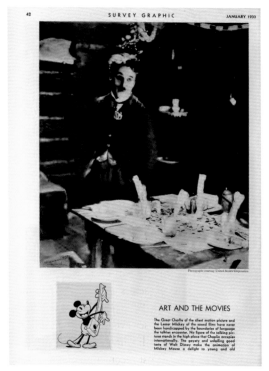

Photograph courtesy United Artists Corporation

ART AND THE MOVIES

The Great Charlie of the silent motion picture and the Lesser Mickey of the sound films have never been handicapped by the boundaries of language the talkies encounter. No figure of the talking pictures stands in the high place that Chaplin occupies internationally. The gayety and unfailing good taste of Walt Disney make the animation of Mickey Mouse a delight to young and old

In January 1933, *Survey Graphic* held up Charlie Chaplin and Mickey Mouse as proof that movies might produce art

boxes used by the Western Clock Company and packages for pharmaceutical products. For a section on 'Art and the Movies', the *Graphic* supplied only two examples: Chaplin and Mickey Mouse, 'the Great Charlie ... and the Lesser Mickey'. For the *Graphic*, Disney was part of the best of modernity, and his production methods, while on a large scale, still resulted in a cultural form that was humane, accessible and original. The studio stood as a sign of the interrelatedness of art and commerce in the twentieth century, just as much as those exquisite living rooms and clock boxes, and was practically on a par with Chaplin, the greatest artist of the cinema.

At about the same time as this assessment in the *Graphic*, Disney expanded his production capacity by moving aggressively into

merchandise connected to his movies. He began licensing his characters, and particularly Mickey Mouse, becoming the first film-maker to exploit the merchandise market systematically, something that would, of course, prove to be an even greater bonanza with *Snow White* and the ubiquitous Dopey dolls and other knick-knacks. But even by 1934, Mickey Mouse watches and pencil sets and dial phones were everywhere, and especially in major department stores. Just as his film production methods made him a hero of modernity without eliciting any of the complaints that so often accompanied the Hollywood assembly line, so too did his film-related goods avoid the criticism that, at the time, was usually directed at any plan that sought to turn children into consumers. As Richard deCordova has pointed out, Disney's 1930s department store products indicated the animator's value as an educator of children, rather than as someone who exploited kids' desires to possess those things that were connected to the cartoons they saw in cinemas.[14]

In fact, Disney's spotless reputation only grew during this period. In 1934, James Thurber, whose sensibility might seem, at first glance, to be at odds with Disney's, wrote about the animator in *The Nation*, then as now the liberal, intellectual magazine of record in the United States. Thurber, of course, was the period's middlebrow figure of disgruntled domestic masculinity, a favourite of a relatively small audience of readers of such upmarket literary sources as *The New Yorker*. And Disney had become the great middlebrow icon of mass-produced art that was both slapstick and, even then, overly sentimental. Thurber, however, began his homage by rejecting Homer's *Odyssey* as well as Joyce's *Ulysses* as imperfect.[15] Then he wrote that his 'purpose' was 'to put forward in all sincerity and all arrogance the conviction that the right *Odyssey* has yet to be done, and to name as the man to do it no less a genius than Walt Disney'. Just six years after *Steamboat Willie*, the first sound cartoon from 'Walter Disney', the animator had become, at least for Thurber and, presumably, others like him, the equal of both the western world's greatest epic poet and its most significant modern novelist.

Thus anointed, Disney became a fitting subject for contemplation in the museum. In 1935, the Museum of Modern Art in New York announced its new series for 1936, 'A Short Survey of the Film in America, 1895–1932'.[16] MoMA planned on showing two films by D. W. Griffith (*The New York Hat*, 1912, and *Intolerance*, 1916), and one each by F. W. Murnau (*Sunrise*, 1927) and Josef von Sternberg (*The Last Command*, 1928), among others. But there were also three Disney films on the schedule: *Steamboat Willie*, *Plane Crazy* (1928) and *The Skeleton Dance*. In the following years, other museums followed suit, and in 1944 Disney himself was made one of MoMA's trustees. *Snow White* became a suitable object for the museum almost immediately upon its nationwide release. The Cleveland Museum, for instance, proudly announced in February 1939 that it had been given 'drawings for *Snow White*' among other recent important acquisitions, including an Alexandrian gold coin, a Steuben bowl and an oil painting by Watteau. By the end of the 1930s and the release of *Snow White*, Disney was considered, then, both a hero of a sort of artisanal mass production in the manner of the Steuben glassworks and an artist of importance beyond the national limits of the United States.

This reputation, as a Whistler and Watteau of aesthetic sensibility and a Thomas Edison of research and design, could not last. Indeed, the period spanning the production of *Snow White* to the release of *Fantasia* (roughly 1935–40) marked an undisputed high point in Disney's film-making and also in the film-maker's cultural standing. The profits from *Snow White* allowed Disney to build his new, ultra-modern studio, the most advanced and technologised movie factory in the world in 1940. And while that film signalled Disney's full ascension into the ranks of major international artists, *Fantasia* only affirmed that status. Although the latter film met with some critical dissent, few thought of it as anything less than astonishing in its technological advances (stereo, for example), and its visual and aural tonal complexities. In 1941, however, animators and other workers at the studio staged a bitter,

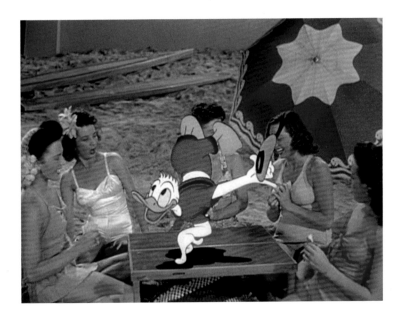

protracted strike, and Disney's reputation now began to shift, from great artist to anti-union boss. His films from that period – *Saludos Amigos* (1942), *Victory through Air Power* (1943), *The Three Caballeros* (1944) and others – often left critics perplexed and occasionally offended: both aesthetically, because of the mixture of live action and animation, and morally, because of the emphasis on 'real' bathing beauties and on Donald Duck's unchecked libido. Disney himself during these years helped facilitate his own shift in the public's imagination, from artist and entrepreneur to right-wing ideologue, as he proselytised heavily against communist influence in Hollywood during the McCarthy period. Disney's television show would rehabilitate his image during the early 1950s, but becoming 'Uncle Walt' to decades of viewers meant that he would never again be considered the perfect American mixture of aestheticism and industry. Thus, *Snow White* signified the very specific apotheosis of a major American artist.

Donald Duck, having arrived in Acapulco, tries to impress bathing beauties in *The Three Caballeros* (1944)

The culture of a classic: *Snow White* before *Snow White*

By 1934, Disney had decided to make a feature film of *Snow White*. The story certainly made sense in the context of the short films Disney had been producing, and it also had ample cultural resonance. There were, of course, the many and prominent literary sources, most notably that of the Brothers Grimm from the early eighteenth century, which was known throughout Europe and the Americas. But in the few decades before Disney's film, and just in the United States, there were many popular versions of the story in various media, versions that familiarised several generations with the significant elements of the story, and that made *Snow White* well known, although not overdone.

A glance at the 'life' of *Snow White* in a single metropolitan area – New York – in the quarter-century before Disney's film indicates the ongoing importance of the story to the lives of children especially. In 1910, *The New York Times* ran an opinion piece in which 'noted theatrical people' discussed the question of 'Sabbath entertainments', which typically were outlawed in the city. The popular and prolific author Marguerite Merington, who had written a stage version of *Snow White*, weighed in authoritatively on the benefits of Sunday shows. Her example was a production of *Snow White* performed by children at the Hebrew Educational Theater. According to Merington, all of the actors were Jews, 'whose Saturday is Sunday', and the performance, with a 'black haired young Jew' playing the prince, was a complete success.[17]

Just two years later, in 1912, another version of *Snow White* opened in New York, this one written, directed and produced by Winthrop Ames, one of the most important Broadway talents of the era. Perhaps indicative of a feminisation of fairy tales in the United States of the early twentieth century, Ames wrote his version under his female pseudonym, Jessie Braham White. But the central concern in the play was age, rather than gender. In covering the opening, the critic for the *Times* seems to have anticipated Disney's own thinking, and argued that this fairy tale, unlike the more adult *Peter Pan* or *Hansel and Gretel*, was the perfect childhood entertainment.[18]

In fact, various theatrical and operatic versions of *Snow White* toured throughout the United States. In Boston in 1914, Ames' play was featured as the Christmas production at the Castle Square Theater. In New London, Connecticut, in July 1915, an amateur production of *Snow White*, either Ames' or Merington's or someone else's, played outdoors, at a benefit for a local hospital, and seems to have been one of that summer's prominent social and cultural events. As just one further example, in 1924, in Hartford, Connecticut, the American School for the Deaf devised a pantomime of the story, which students performed in a series of evening and matinée shows.[19] From amateurs to professionals, from Jews performing on Sundays to kids playing most of the prominent roles, from adult audiences to children, *Snow White*, in one version or another, emerged as one of the period's perfect vehicles for all audiences and production circumstances.

Snow White turned up throughout the period in different media and venues. In 1926, McClure Newspapers syndicated a *Snow White and the Seven Dwarfs* comic strip, and four years later in New York, and around Christmas – the time for so many revivals of the story – *Snow White and Rose Red*, 'a fairy-tale in four scenes', was performed on stage at the Roxy Theater, accompanying the new Leo McCarey film *The Shepper-Newfounder*, and shared the bill not only with the latest instalment of a *Movietone* newsreel but also with the Disney cartoon *Midnight in a Toy Shop*.[20] The story even made international news, as in Berlin in 1934, when the convention of National Socialist Teachers, anticipating the work of psychoanalyst Bruno Bettelheim by forty years, sought to uncover the deep meaning of fairy tales, while claiming them as fully nationalist narratives. For these fascist German educators, *Sleeping Beauty* represented Adolf Hitler as 'the man who with a kiss awakened the sleeping soul of the German nation', while *Snow White* symbolised 'the German soul', with the evil stepmother embodying the unholy trinity of 'communism, Catholicism, and capitalism'.[21]

So for the thirty-five years or so before Disney's version, different incarnations of *Snow White*, while not ubiquitous, were

abundant enough. And of special interest here, there were significant film versions. Early American film pioneer Sig Lubin produced a version of *Snow White* in 1902, but prints of the film, and much other information about it, are scant. The Famous Players Film Company produced the first major *Snow White* film in 1916, with a screenplay by Winthrop Ames (who, as we have seen, had adapted the fairy tale for Broadway a few years earlier). There was at least one other link between that play and the film. Marguerite Clark, an adult actress who had played Snow White in Ames' stage version, and who made a formidable career out of portraying young girls, starred as the title character in the movie.

Unsurprisingly, this *Snow White* anticipates the narrative contours of the 1937 version, because the film made a deep impression on Disney when he saw it at a special matinée showing for newsboys in Kansas City. In 1938, he told an interviewer that 'One of the pictures he remembers best out of his childhood was … *Snow*

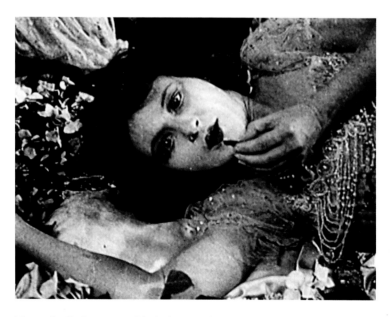

Marguerite Clark as Snow White in the 1916 silent film

White and the Seven Dwarfs', although 'childhood' may be a bit of a stretch here, as Disney would have been fifteen at the time of the screening in January 1917, and very much the aspiring high school artist.[22] He would often recall the occasion, so the movie viewing seems less the apocryphal publicity piece designed to ballyhoo the 1937 film, and much more a formative experience for the animator. He remembered the film as much for the details of its exhibition as for the story. The special screening took place at the Kansas City Convention Hall, and the movie was projected simultaneously on four screens arranged in a square, so that from his seat, Disney saw the film on two screens at the same time. A little over a year later, an underage Disney bluffed his way into World War I and the Red Cross ambulance corps, so this extraordinary event in Kansas City may well have figured as one of the last significant acts of a Midwestern 'childhood' before his experiences in France (although Disney did not arrive until almost a month after the end of the war).[23]

The 1916 film, even without its unusual exhibition, was not without its appeal, especially to a young man with an aesthetic sensibility. The movie begins with a charming set piece in which dolls representing all the principal characters come to life. The 'real', heavily made-up dwarfs are much more ominous than their animated counterparts in the later film, and Disney, always concerned about characterisation, changed their names, from the mostly rhyming but otherwise meaningless – Blick, Flick, Glick, Snick, Pick, Whick and Quee – to those indicating the personality traits that we know so well today (Bashful, Grumpy, Sneezy, etc.). And Marguerite Clark's Snow White, part young girl and part woman, in the manner of so many of her film roles and also a type popularised at the time by Mary Pickford, certainly looks forward to Disney's animated princess.

Perhaps indicating the success of the Marguerite Clark feature film, Universal seems to have released a short three-reel *Snow White* just one year later. But the most impressive and most enduring version, in no small part because of how different it seems from

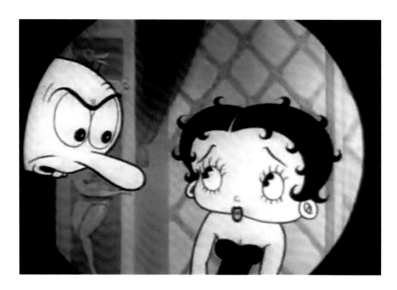

Disney's film, is a cartoon from 1933, with Betty Boop in the title role. The Fleischer Brothers, making their films in Florida and releasing them through Paramount, had begun developing Betty as a star in 1930, in *Dizzy Dishes*. Within a year, they were turning out Betty Boop cartoons with Mickey Mouse regularity: from 3 in 1930 to 9 in 1931, and then 25 in 1932. During this period of her growing popularity, she appeared in at least one cartoon based on a fairy tale, *Jack and the Beanstalk* (1932), and in 1934 she would appear in a Technicolor *Cinderella*.

Betty's *Snow White* begins conventionally enough, with an evil queen, her looking glass and Boop in short skirt and garter belt coming to the castle. The queen wants Betty killed because of her beauty. But once Betty escapes from this danger, the familiar story changes considerably. Having become encased in a block of ice, Betty arrives at the dwarfs' house. All of this acts as preamble to Koko the Clown, a frequent co-star in *Betty Boop* films, singing 'St James Infirmary Blues' as the dwarfs carry Betty, still on ice, as if they were pall-bearers preparing her for her funeral. At the end of the number

Betty Boop meets the Evil Queen in Paramount's 1933 version of the fairy tale

and the end of the film, Betty, Koko and Bimbo their dog manage to thwart the queen, who has returned as a dragon.

In this film, as in so many others, Koko the Clown has been rotoscoped: that is, a live-action actor has been filmed, and then that film has been traced and turned into animation. The Fleischers pioneered the technique, but it was then employed extensively by Disney, although his animators tended to use it for reference rather than tracing (dancer Marge Champion, then married to Disney animator Art Babbitt, worked as the rotoscoped reference model for Snow White). But here the similarities with Disney end.

A straight line connects Marguerite Clark's adult but adolescent sexuality with Disney's Snow White. But Betty's trademark 'boop-oop-a-doop' is, to say the least, much more fully grown up. Like Disney's films from the period, the Fleischers' cartoons typically made full use of music, but while Disney tended towards a middlebrow homogenisation of European classical styles, the *Betty Boop* series often showcased African-American jazz. In *Snow White*, Cab Calloway provided the voice for Koko's rendition of 'St James Infirmary Blues'. Calloway had sung before in a *Boop* film, in *Minnie the Moocher* from 1932. Indeed, dancing in front of his orchestra, Calloway had appeared as himself in an extended prologue to that film. That same year, Louis Armstrong appeared with Betty in *I'll Be Glad When You're Dead You Rascal You*, singing and playing the title song with his band.

The point here is not that the Fleischers, with Betty Boop, showed more progressive attitudes about race than Disney. After all, when Armstrong appears at the end of *Rascal*, he is superimposed over an animated, and all too familiar, African savage, hardly any better in its way than the crows in Disney's *Dumbo* (1941) who perform a blackface 'When I See an Elephant Fly'. Instead, at least in part to differentiate their films from the dominant Disney product, the Fleischers sought to invoke different cultural models, and the two versions of *Snow White* (theirs and Disney's) show some of the extremes, in terms of musical sensibility and the representations of

race (as well as female sexuality), available to films designed for a national, predominantly white audience.

Two of Disney's own films from this period present the best blueprint for *Snow White*, and also chart his developing ideas about narrative, music, character and industrial practice. The studio released *Flowers and Trees* in 1932, followed by *The Three Little Pigs* a year later, and those films led directly to the look and sound of the 1937 film. *Flowers and Trees* holds a special place in film history as the first cartoon made in the new three-colour Technicolor process, which produced a far fuller spectrum of colour than previous systems. Just as he had with sound a few years before, Disney enthusiastically adopted the new process; in fact, he had already begun *Flowers and Trees* in black and white, but scrapped that footage and began again in colour. While certainly fully committed to the benefits of aesthetic improvement, Disney also understood the industrial advantages, at least for his studio, of new technologies.

By committing to make all *Silly Symphonies* in colour (although not the more successful *Mickey Mouse* films), Disney served notice to all other cartoon producers that he meant to differentiate his product even further from the standard animated film. Disney – or, more properly, his brother Roy, who handled most business matters – even convinced Technicolor to give him exclusive rights to the new process for two years, effectively stifling any significant competition. Just as he had with sound, Disney immediately took advantage of a new technology to create a special status for his product and his studio, which now, while unable of course to compete with the fully diversified major companies like MGM or Paramount, could turn out something that they could not – a Technicolor cartoon.

Flowers and Trees tells its story not with words, but with music. The film begins with the forest waking up, all the flowers and trees and toadstools and birds, to the accompaniment of an orchestral string section. The film tells the story of a romance between two trees

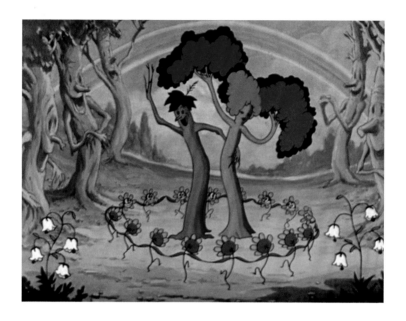

and the threat posed by an evil stump. A forest fire destroys the stump, and after an air squadron of birds puts the fire out, the two trees are married, with the 'Wedding March' playing in the background. But this narrative remains secondary to the mood of the film, to the lushness and dimensionality of the image of the full-colour forest, and to the way the music, with its snatches of European classical styles, produces something of a nature's idyll of movement and sound. The film won an Oscar as Best Animated Short, certifying Disney's confidence in colour. More importantly, it showed the possibilities of the merging of sound and colour, of classical and popular musical styles, and displayed a richness of image never seen before in cinema that would be so fully developed over the course of the *Silly Symphonies* and perfected in *Fantasia*, but which enjoyed its first extended, and triumphant, test in *Snow White*.

Another *Silly Symphony*, from 1933, was less a tone poem of the aesthetic possibilities of animation and more driven by character

The marriage at the end of *Flowers and Trees* (1932)

and narrative, with music fundamental to both, all elements so central to *Snow White*. Even more importantly, *The Three Little Pigs* was a bona fide sensation, still almost certainly the most popular non-feature-length film ever shown in the United States.

Coming after the successes of *Steamboat Willie*, *The Skeleton Dance*, *Flowers and Trees*, and so many others, *The Three Little Pigs* must have confirmed for Disney that cartoons alone could attract massive audiences, and that an animated feature might challenge any film from a major studio.

The film tells the familiar story of the three little pigs and the big bad wolf. Disney's animators gave all of the characters broad but specific personality traits: two of the pigs are lackadaisical and slapdash while building their houses, the other industrious and hard-working, while the wolf, of course, is determined to have ham for dinner. Songs tell most of the story, with the famous 'Who's Afraid of the Big Bad Wolf?' emerging at the beginning of the film as an anthem to laziness, and at the end as a tribute to constant preparedness. In the lead-up to the production of *Snow White*, this cartoon short established a plan for the feature film, not only through the music- and song-driven narrative but also with its fully differentiated characters. Thus, the three pigs served as a trial run for the seven dwarfs.

The short film was an astonishing success, playing week after week in some cinemas at a time when cartoons typically showed for no longer than a week in most cities and less than that in small towns. Conventional wisdom has it that the film somehow touched a nerve during the Depression with its all-for-one vanquishing of the wolf, himself a metaphor for the dangers of hard times.

This explanation seems somewhat too pat, too determined that all audiences understood the film in the same way. Nevertheless, the film generated headlines like '*Three Little Pigs* Persist' when it was held over for yet another week, while Mordaunt Hall, *The New York Times* film critic who hardly endorsed the lowbrow and popular entertainments of most American movies, said of the film that 'one

could witness [it] again and again and always enjoy it'.[24] For Disney, the people and the critics had spoken. *Flowers and Trees* and *The Three Little Pigs*, as well as the successes of his other films, convinced him of the possibilities and benefits – in terms of aesthetics, music, narrative and industrial advantage – of a feature-length cartoon.

2 Production

We can take a broad view of what 'production' might mean in relation to any film. But particularly with *Snow White*, which was such an extraordinary project during all phases of production, the term takes on multiple meanings. Production, of course, means the making of a film, and critics and regular film fans of the time regarded *Snow White* as a marvel of modern movie labour practices. We might also consider, though, the decision to make the film and the introduction of the idea of a feature-length cartoon to the public as an aspect of a movie's production, providing audiences with a sense of a film's form and content long before any footage has been shot. Another significant part of the production process comes later in the life of a film, with the arrangement of distribution and exhibition agreements, domestically and internationally, and here *Snow White* marked an important shift in Disney practices. Finally, production might also mean the presumed influence, while a film is being made, on other films in the planning stages. And here, industry insiders and critics believed that Disney's experiment would have a profound effect on the films produced between 1938 and 1940.

We cannot know absolutely for certain when Disney decided to make a feature-length cartoon, and that it should be *Snow White*. As with so many of his decisions, we can assume that he was motivated in part by artistic considerations and also by the challenges involved. Disney took quite seriously the aesthetic improvement of animation, and so a feature-length film, with a full story and a significant musical score, must have seemed like a logical step in the medium's development. But there were also important economic limits to the continued production of cartoon shorts. Disney himself lamented that it could take eighteen

months to recoup the costs of a cartoon short, in large part
because cinemas objected to paying high rental fees for movies
that, despite their quality, were seen as secondary to the feature
films that they supplemented.[25]

News about the feature-length cartoon first came to public
attention in the middle of 1934. In July of that year, the *Los Angeles
Times* headlined, '*Snow-White* Legend to Be Made in Color', and the
article claimed, 'It was inevitable, of course, that Disney should make
a full-length picture.'[26] A month earlier, Disney had told *The New
York Times* something of his decision-making process.[27] He revealed
that he had given some thought to making a feature film of *Alice in
Wonderland*, as a part live-action, part animated film, much like the
Alice shorts he had made in the mid-1920s. Disney's new *Alice* would
have starred Mary Pickford, who would soon retire from movies but
whose ongoing celebrity and expertise at playing adolescent girls
made her a compelling choice for the role.

Disney rejected that idea, and instead committed his studio to
Snow White and the production of a film with 'a full symphony
orchestra and fine singers' that would cost 'a quarter of a million'
dollars.[28] That number may have seemed eye-popping at a time when
most live-action features cost far less, but Disney had miscalculated
by a significant magnitude. By the time the film opened in Los
Angeles, production costs had soared to at least $1.5 million. But the
cost of the film, and the number of frames and pictures, as well as
labourers, needed to make the movie, created much of the ongoing
drama of *Snow White*'s production.

The labour of animation

The story of the making of *Snow White* has been told many times.
The credits for the film give some partial sense of the different
jobs and the separation of labour required by Disney's methods:
1 supervising director (David Hand), 5 sequence directors, 4 supervising
animators, 2 character designers, 10 art directors, 24 animators,
7 background animators, etc. With the exception of Dorothy Ann

Blank, one of eight credited with the story adaptation, and Hazel Sewell, one of the ten art directors, men made up the credited workforce. This sort of division of labour typified the Hollywood studios, of course, but recently we have learned much more about the gendered dimension of work on the film. Journalist Patricia Zohn related the memories of her aunt, who had worked at the Disney Studio, and also interviewed other women who had contributed to *Snow White*.[29] These women, at least a hundred or so, had been the inkers and painters for the film, those artists who, wearing white gloves, outlined on cels the pencil drawings made by the various animators and inbetweeners, and then painted them. In the Disney hierarchy, this was menial work, but the boss was still highly selective. One of the women remembered that, out of a class of sixty being trained for the job, Disney chose only three. The women worked long hours, especially towards the end of the production, for a starting salary of $16 a week.

Men held most of the important production positions during the making of *Snow White*, but a theatrical trailer for the film stressed the anonymous women who worked in Disney's art department

None of the performers in *Snow White* received any screen credit. The voices involved belonged to some of Hollywood's better-known character actors, for instance Billy Gilbert, who played Sneezy (and who himself had achieved some renown for his remarkable sneezing skills in many movies). Moroni Olsen, who had made his film debut as Porthos in a 1935 production of *The Three Musketeers*, played the Magic Mirror, informing the Queen just who was fairest in the land. Lucille La Verne, a well-known stage actress who had already appeared in dozens of films (including Griffith's *Orphans of the Storm*, 1921, and *Abraham Lincoln*, 1930), gave voice to the Queen, a performance that has frightened generations of small children. Disney also looked to experienced and reliable animation performers. Pinto Colvig, for example, who previously had played Pluto and Goofy, gave a voice to both Sleepy and Grumpy. Disney wanted new performers for the roles of the Prince and Snow White. In the former role, he cast Harry Stockwell, a singer who had appeared in just a few films, and who is known to us now, if at all, as the father of actors Dean and Guy Stockwell.

The voice of Snow White was performed by Adriana Caselotti. Coming from a family of opera singers and music teachers, she was eighteen when Disney discovered her and twenty-one by the time the film premiered. Disney kept her under an exclusive contract for many years and was determined that Snow White's voice should be associated solely with the cartoon character and not the real woman, and so Caselotti's career as a popular singer began and ended with this animated feature.[30] Disney adopted a similar strategy for all of the foreign-language versions of *Snow White* playing in different parts of the world. For the French audiences who would see *Blanche-Neige et les sept nains*, for example, he had considered renowned opera singer Lily Pons for the Princess' songs, but instead settled on a relative unknown for the role, Elyane Célis (Lucienne Dugard provided the speaking voice for Snow White).[31]

While still failing to say much about the performers over the years, the Disney Company itself, through its publishing wing

Hyperion, has given us the most exhaustive account of the production of the film, in *Walt Disney's Snow White and the Seven Dwarfs: An Art in Its Making* (1994).[32] The book breaks the film down to its smallest parts. *Snow White* eventually contained fifteen numbered sequences and slightly over 700 scenes. Disney assigned each scene to an animator and a background artist, both of whom had also been given a prearranged amount of film footage for the scene. Utilising the newly developed multiplane camera, which gave such impressive depth to so much of the movie, the crew filmed many scenes in a number of overlapping cels: according to a 1937 estimate – probably too modest – around 250,000 cels had been used in the final film. The book reported that about 750 artists contributed to *Snow White*, among them 66 inkers, 178 painters, 32 animators, 102 assistant animators and 107 inbetweeners, those artists who filled in the work of the animators, who themselves drew only several distinct stages of each character's movements.

The public were well aware of the labour involved in the film, as the production of *Snow White* turned into a significant news story throughout the mid-1930s. Once we separate Disney press releases, which can be somewhat suspect, from actual reporting, these stories provide valuable information about the making of the film, and also indicate a high level of general interest in the nuts and bolts of producing an animated feature. In December 1935, a full two years before the premiere of *Snow White*, *The New York Times* ran an interview with Disney, some of which centred on the film.[33] Asked when his first feature-length cartoon would be finished, Disney answered, optimistically, that he hoped to complete the film 'early in 1937'. In response to a question about the number of drawings it would require, which seemed to indicate an understanding of the almost unthinkable amount involved, Disney responded initially with the precision of a scientist, and then with the unknowability of an artist. He said the film would be six to eight reels long, and that each reel would be made up of 16,000 frames. However, given that 'each frame is a composite of from one to five individual drawings', all

estimates were off the table: 'It is impossible even to roughly estimate the total number of drawings.'

As the film neared its Christmas release, stories about the intensity of the working conditions at the Disney Studio only increased. As early as May 1937, newspapers discussed the seemingly inch-by-inch progress on the film, and claimed that *Snow White* had set a standard for being painstakingly overdue unmatched even by David O. Selznick's much-anticipated leviathan: *Snow White* 'started being slow a long time before *Gone With the Wind*', *The New York Times* claimed. Two months before the opening, the *Los Angeles Times* reported that *Snow White* now utilised 'the entire resources of the [Disney] plant's 700 employees all day and two nights a week', even after almost four full years of work on the film. Just a month before the opening, the *Times* revealed that Disney had added a night crew to the production, and that in spite of the increased labour force and working hours, 'only a limited number of prints [of *Snow White*] will be available for Christmas showing'.[34] These reports sound accurate enough, and they show us the immensity of the challenge that Disney faced in making a colour feature-length cartoon. They also tell us that the public found the story of the production of the film itself compelling, and that the work involved in making a movie helped generate interest in seeing the finished film.

As further evidence of this interest, a number of stories appeared about the more trivial aspects of the production. In the months preceding the film's release, the public – and potential audience – learned that animators modelled the eyebrows for six of the dwarfs (all except Happy) after Disney's own. And despite the impressive technologies used on the film – the multiplane camera, Technicolor – animators still used old-fashioned know-how when it mattered most. For the sound of the dwarfs' organ, and despite their best efforts at inventing something new, 'technicians found that by blowing on bottles partly filled with water they had exactly what they were looking for'.[35]

The impact on Hollywood

The very production of *Snow White* seemed to signal a new interest in cartoons in Hollywood. The press reported that 1937 would be a 'banner year' for cartoons, with the team of Hugh Harman and Rudolf Ising, who produced cartoons for MGM, increasing their annual output from 13 animated shorts to 18, and Leon Schlesinger at Warner Bros. expanding production from 26 *Looney Tunes* and *Merrie Melodies* to 34. There could be no doubt about the reason for this development: 'the possibilities for [animation's] coming of age with the Walt Disney super-feature production of *Snow White*'.[36]

Some of these numbers were about right and some remained inflated, but they always reflected the impact *Snow White* had on the industry. Warner Bros. indeed increased its cartoon output from 25 in 1935 to 35 in 1936 and 36 in 1937. MGM's cartoon production, however, went up from just 9 animated shorts in 1936 and 8 in 1937 to 15 in 1938 and 14 in 1939. Trying to compete with Disney, Paramount released the Fleischer Brothers animated colour feature *Gulliver's Travels* in 1939. Film historians often speak of single films sparking shifts in production. For example, *It Happened One Night* (1934) virtually created the romantic sound comedy, as every studio tried to copy its success; while *Stagecoach* (1939) initiated a vogue for adult Westerns. These claims are usually overrated. But in the case of *Snow White*, we have a film that, for a few years at least, changed the production practices of the major Hollywood studios, and moved animation from the margins of film production much closer to the centre.

As well as beginning a trend, as it did with cartoon production, *Snow White* contributed to an ongoing development in Hollywood – colour films. Of course, Disney had been a pioneer when he made his commitment to Technicolor long before any other studio. The first Hollywood feature in the new three-colour Technicolor process, *Becky Sharp*, appeared in 1935, a full two years after Disney's *Flowers and Trees*. With *Snow White*, Disney reconfirmed his own interest in colour, and this time, rather than acting alone, he took part

with other producers in Hollywood's long, slow transition to colour production that would take decades to complete. For the 1936/7 film production season, Technicolor's plant would be running at full capacity, which meant that some producers who hoped to film in colour might be disappointed. The number of colour productions at the time seems tentative by later standards, but nevertheless marked a major increase for the film industry, with Paramount, for instance, planning two colour films, and 20th Century-Fox one (*Ramona*, based on the longtime bestseller by Helen Hunt Jackson).[37]

Following Disney's model, smaller but nonetheless important studios made a fuller commitment to colour than the major firms. Independent producer David O. Selznick planned three Technicolor films for 1936/7. And naturally enough, Pioneer Films, owned mostly by John Hay Whitney, who also controlled Technicolor, planned a number of films to showcase the new process. But between *Becky Sharp* and *Gone with the Wind*, *Snow White* stood out as the jewel of the new technology, one that would fully demonstrate the complete range of expressive and narrative possibilities in the colour film. As the *Los Angeles Times* reported just a few days before the premiere, 'the Disney feature, *Snow White*, is what has caused the studio establishment to become color-minded'.[38]

Signing with RKO

Disney maintained its status as a minor studio in no small part because it lacked the apparatus to distribute its own film to cinemas. Before *Snow White*, Disney distributed his films through United Artists, a boutique company by Hollywood standards, founded by film-makers who took themselves seriously as artists – D. W. Griffith, Charlie Chaplin, Mary Pickford and Douglas Fairbanks – and among whom Disney fitted in extremely well. Wanting to maximise the profit potential of his first feature, though, Disney left UA in 1936, and signed a distribution deal with RKO, a fully integrated major studio that produced and distributed films, and then exhibited them in major cities in cinemas owned by the company. This move to a

much more powerful company, and one that owned many more cinemas, guaranteed *Snow White* a wide audience, and also meant a New York opening at the most prestigious venue in the country, RKO's Radio City Music Hall.

RKO also benefited, of course, from the Disney deal. In addition to all of the short films, Disney promised RKO one feature-length cartoon a year. Even before completing *Snow White*, Disney announced, in the summer of 1937, that he had acquired the rights to Felix Salten's bestseller *Bambi*, which he hoped to make as his second feature-length cartoon (although *Bambi* would not be finished until after *Fantasia* and *Pinocchio*, 1940). For all of Disney's films, RKO had access to theatres worldwide, and the financial possibilities of those foreign sites made up a significant part of the appeal of doing business with Disney. Disney's cartoons had always been extraordinarily popular in the UK, for example, and as a result a group of major British exhibitors began negotiating with RKO for the rights to *Snow White* at the then unheard of price of $1 million.[39]

Disney and RKO remained in business together until 1953, when Disney formed the Buena Vista Distribution Company and began distributing its own films. So *Snow White* changed not only Disney's status as an aesthetic visionary, fulfilling as it did the promise of the short films. This first animated feature also changed Disney's position in the industry, aligning him with one of the five most important studios – the others were Warner Bros., 20th Century-Fox, Paramount and MGM – and placing his product front and centre in the most important exhibition venues in the United States and, indeed, the world.

Advance word about the finished film began in the summer of 1937, when Disney showed portions of *Snow White* at the RKO sales convention in Hollywood, where the studio's national distribution staff, responsible for booking the film into cinemas, responded to the snippets with great enthusiasm.[40] By the time the film neared completion, the Disney and RKO publicity machines worked

assiduously to make the public aware of *Snow White*. In just one example among many, in the major cities where the film opened, in early December, three weeks before *Snow White* appeared, Robinson's department store in Los Angeles merged its retail space with Disney's cartoon. Robinson's was an upmarket store, and in their newspaper advertising for various products appealing to women, from silver fox capes to eastern mink coats to down comforters, they announced that the fifth-floor toy department would stage a free puppet show based on Disney's *Snow White and the Seven Dwarfs* every hour on the hour.[41] Disney products had figured prominently in department stores nationally for several years by this time, but here the item was nothing that could be purchased – no Mickey Mouse watch or pencil box. Instead, the store became a theatrical space, providing publicity for a film that had yet to come out, and encouraging the consumers in the store to become consumers at the cinema.

The last-minute work on the film finished, a relieved and smiling Disney arrives at the world premiere of *Snow White*, in Los Angeles, December, 1937

The premiere

The barrage of advance publicity lasted until the evening of the Los Angeles premiere, and radio, even more than newspapers, was Disney's medium of choice. The day before the opening, on 20 December 1937, Edgar Bergen devoted a segment on his popular Charlie McCarthy radio show to a *Snow White* sketch. Then, on the next day, radio station KECA broadcast the premiere of the film nationally, 'from the forecourt of the Carthay Circle Theater', with well-known emcee Don Wilson interviewing Disney characters as they entered the cinema. Just before the opening, the radio reporter who planned to cover the event wrote, 'usually, such presentations are dull as ditch-water, but the Disney magic touch will be felt [tonight], you may be sure'.[42] The radio broadcast of the premiere of *Gone with the Wind*, almost exactly two years later, has probably replaced this one as the quintessential tie-in of radio and movies. But with *Snow White*, leading up to and including the premiere, Disney fully demonstrated the possibilities for using all available media and multiple spaces of consumption (for example, the department store) to prepare an audience for a significant movie event.

Disney used the same strategy across the country, as the film opened in cinemas in different cities and towns throughout 1938. One example

A February 1938 advertisement for *Snow White* merchandise from the *Chillicothe (Ohio) Constitution-Tribune*, at the time of the film's distribution throughout the US

illustrates the national practice. *Snow White* opened in Chillicothe, Missouri, on 19 March 1938. For a full two months before that, Disney advertised the film locally, mostly through products associated with it. On 29 January, the *Chillicothe Constitution-Tribune* ran a story, almost certainly supplied by Disney, about high-fashion hats modelled after those in the film, with one 'smart debutante' after another purchasing Snow White's blue felt bonnet, and even 'Grumpy's peaked hat'. One month later, Kroeger's department store in Chillicothe announced that it would be selling a complete set of glasses, filled with peanut butter, salad dressing or sandwich spread, and decorated with the movie's characters. Then, in the days leading up to the premiere, Disney announced that the film would open in Chillicothe on a Saturday instead of a Sunday, to give local kids more chances to see it right away.[43] So the 'production' of *Snow White*, in the sense of producing knowledge, interest and an audience for the film, continued for the better part of a year after the premiere, as the movie reached viewers throughout the United States.

3 The Film

The narrative

The narrative construction of *Snow White* is simple enough, and hardly remarkable. The film begins with a book, and the viewer reads, 'Once upon a time'. This beginning places us squarely in the realm of the fairy tale and situates the story fully in the literary tradition, in the world of the Brothers Grimm and others who wrote versions of *Snow White* that preceded Disney's film.

In the manner of so many movies, the film quickly establishes its central conflict and hints at its resolution. That book in the opening tells us that there was a 'lovely little princess named Snow White', and that 'Her vain and wicked stepmother the Queen feared that some day Snow White's beauty would surpass her own.' As a result, the Queen dressed her 'in rags and forced her to work as a scullery maid'. Then, when the Queen consults her mirror, she discovers that Snow White is now, indeed, fairer than she. The film cuts to Snow White scrubbing the floor, reduced to servitude by the Queen. And so, with the incredible economy of the Hollywood narrative, we have been introduced to the history leading up to the film and to the conflict between its two central characters.

While she scrubs, and with birds humming around her, Snow White sings 'I'm Wishing for the One I Love'. Soon the Prince enters, singing 'One Love'. He and Snow White meet and then they part, but we know that they are destined to become a couple, just as we realise that the Queen will be the force that keeps them apart. Thus, in just a little more than five minutes, we have seen a condensed version of the story to come.

The rest of the story is familiar, not only because of the commonplaceness of *Snow White* versions, but because it hardly deviates from so many fairy tales about princesses in difficult

circumstances. Snow White's life is endangered when the Queen orders the huntsman to kill her; the kindly huntsman allows her to escape into the forest; at first terrified by her strange surroundings, Snow White finds the dwarfs' cottage and is charmed by it; she cleans the dwelling and then goes to sleep; the dwarfs return from their work in the mine and, mirroring Snow White's fear in the forest, are frightened at the signs of an intruder; when they meet her, they are of course immediately taken by her, with only Grumpy holding out for just a little while; the Evil Queen, learning that Snow White still lives, decides to kill the Princess herself, with a poison apple; transformed into a hag, the Queen goes to the cottage and convinces Snow White to take a bite; the dwarfs return too late, and even though they make the Queen fall off a cliff, they cannot save Snow White; despondent, they place her in a glass coffin, but they do not bury her; the Prince hears of her fate, and by bestowing love's first kiss brings her back to life; Snow White kisses the dwarfs goodbye and leaves with the Prince.

Snow White relates its story in a manner common to many Hollywood films, employing a present tense that indicates duration and repetition. The instance of Snow White scrubbing and singing represents the years of her servitude. The scene of the dwarfs digging in the mine stands for all of the days, months and years of their work. The extended sequences of the dwarfs cleaning their hands on Snow White's orders, and then singing their yodelling song and dancing with her, imply all of the ways that Snow White has changed their lives. When Snow White sings 'Some Day My Prince Will Come', we know that this single scene stands for a lifetime of yearning. When we see the dwarfs mourn at the glass coffin, we understand that this scene has been repeated many times over a prolonged period. In this way, a story that, for the most part, seems only to cover a few days really extends for a very long time, with most scenes indicating others that an eighty-minute movie simply cannot show.

While this storytelling style typifies Hollywood cinema, the construction of *Snow White* also refers to the narratives of so many

fairy tales and folk tales, over time and in different media. In fact, the narratives of these tales had been important objects of study for literary critics throughout the nineteenth and twentieth centuries (the Brothers Grimm themselves were folklorists, collecting and analysing tales throughout the early to mid-1800s). The construction of these tales, the elements that went into them, became established as apparently constant aspects of the fairy tale and folk tale, with rules as rigid as anything one might find in the novel or symphony. In the most comprehensive analysis of these stories, the Russian formalist critic Vladimir Propp compiled their narrative rules in his *Morphology of the Folktale*, which first appeared in 1928. Disney certainly had never read Propp when he decided to produce *Snow White* (the book was not translated into English until 1958), but the film nonetheless conforms to so many of the stories that the theorist had studied.[44]

Pared down to its most basic elements, *Snow White* tells its story this way: 1) A conflict exists between mother and stepdaughter; 2) The stepdaughter's life is threatened; 3) She escapes; 4) She begins a new life far from the original danger; 5) The danger re-enters her life; 6) The young woman suffers terribly; 7) In a happy ending, she is rescued by her true love. While this skeletal narrative conforms to so many other folk tales and fairy tales, the film has also been selective in developing its story. Most famously, psychoanalyst Bruno Bettelheim, in his 1975 book *The Uses of Enchantment*, placed the film (without ever really referencing it) within a tradition of varying *Snow White* stories.[45]

Bettelheim acknowledged the multiple versions of the story 'in all European countries and languages', and then he implicitly criticised the Disney version, writing that '*Snow White and the Seven Dwarfs*, the name by which the tale is now widely known, is a bowdlerization which unfortunately emphasizes the dwarfs.' For Bettelheim, the truest versions of the story begin with information that the film elides: a royal couple finds a young girl with skin white as snow, cheeks red as the rose and hair black as a raven. While the

husband wants to raise the girl as his daughter, the wife schemes to banish her. This *Snow White* tells the story of the Oedipal desire between a father and daughter, and the mother's jealous understanding that her position in the couple is threatened by the young girl.

By omitting this, versions like Disney's, according to Bettelheim, ignore much of the psychoanalytic importance of fairy tales in general, the working through of Oedipal relationships, the separation of child from parent, the development of fully adult sexuality. Some audiences at the time of the initial release of *Snow White*, as well as more recently, may have been struck by the film's not always subtle sexuality: Snow White herself hovering between adolescence and adulthood; her breathy voice; the determination of the film to place her in a romantic couple; let alone the Evil Queen's pin-up figure or the comic, phallic imagery of the dwarfs' noses poking over the bed on which Snow White sleeps when they first encounter their

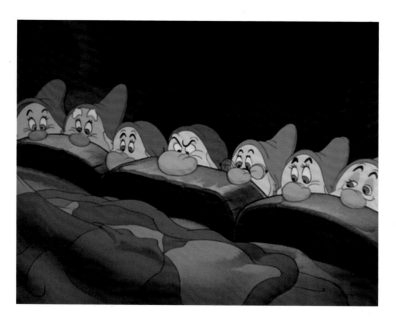

The dwarfs' noses peek over the beds in the cottage

new visitor. For Bettelheim, the film and other versions like it are not sufficiently concerned with sexuality and the development of mature sexual attitudes. By concentrating on the dwarfs, the film emphasises those who fail 'to develop into mature humanity, [and] are permanently arrested on a pre-oedipal level'.

Regardless of their physical, sexual or emotional development, or perhaps in some part because of it, the dwarfs motivate the most frightening scene in the film, and indeed one of the most frightening in the entire animated canon. Alerted by the forest animals that the Queen has a poison apple intended for Snow White, the dwarfs decide to stop her. They hop onto deer and race back towards the cottage, arriving just as the Queen is leaving – Snow White already having taken a bite – and chase her through the forest. The Queen comes to a precipice and tries to roll a gigantic boulder onto the dwarfs. Instead, though, she falls to her death, and buzzards swoop down on her as the scene fades to black.

This, really, is the emotional high point of the film. While the next and final scene in *Snow White* fulfils the requirement of a Hollywood happy ending, as the Prince awakens Snow White, it also seems tacked on and practically superfluous. Indeed, the end of the Queen and the ending of *Snow White* have interesting histories in cinema. The 1916 silent *Snow White*, at least the extant version, simply refuses to tell us what happens to the Queen. In that film, she makes repeated efforts to kill the Princess. First, transformed into the familiar old hag, she poisons Snow White with a comb that will kill her at the count of one hundred, but the dwarfs rescue her just in time. Thus thwarted, the Queen changes her gender and comes to Snow White in the guise of a pieman, offering her a deadly apple. After that, the Queen vanishes from the film, the Prince awakens Snow White, and all ends happily.

In Betty Boop's 1933 *Snow White*, the Fleischer Brothers play the Queen's demise for comic effect. Transformed into a dragon, the Queen chases Betty, Koko and Bimbo the dog, to the accompaniment of a jazz score. But then Bimbo stops running and tugs on the dragon's

As the dwarfs force the
witch to the precipice,
she falls to her death,
and from above
buzzards fly down to
investigate

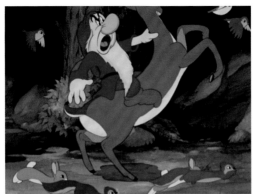

When the dwarfs begin their rescue attempt, the sequence is marked by dynamic shifts in space and scale, from the dwarfs, to Snow White tasting the poison apple, to the witch trying to escape

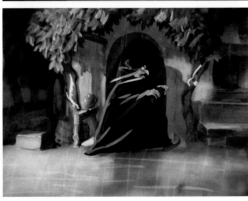

tongue. The dragon runs away, and everything ends happily for Betty and her friends. In Disney's film, however, the chase and subsequent death of the Queen is treated in deadly seriousness, as the dwarfs shout 'After her!', invoking nothing so much as the end of *Frankenstein* (1931), when the villagers pursue the monster and then burn him alive.

The scene is a remarkable four minutes of graphic dynamism and narrative movement. From the moment the dwarfs hop onto their deer to the fadeout after the Queen's fall, there are some forty-seven shots, an extraordinary number in such a compressed time, especially in a film that, in most sequences, delights in the slower pace afforded by a feature-length cartoon rather than the standard short. The only other similar scene is Snow White's flight through the forest as she escapes the huntsman; but this contains far fewer shots, and from the moment the huntsman raises his knife to the shot of Snow White on the ground, recovering from her faint in a peaceful rather than terrifying forest, only about two minutes have elapsed.

During the dwarfs' pursuit of the Queen, practically every shot changes the viewer's orientation, while never causing any confusion about the space of the action or the dwarfs' physical relation to the Queen. The editing of the chase scene lets the audience recognise and understand the multiple spaces and angles, while the rapidity of the shots reinforces the dwarfs' urgency and anger, and the Queen's fear. During the pyrotechnics of the chase, we become aware of at least three planes of action: the frantic space occupied by the dwarfs as they charge from screen left to right, and also that of the Queen running away ahead of them; and then, as the pursuit nears its end, the slower, more contemplative space inhabited by the buzzards high above waiting for the chance of a meal. Percussive music and the sounds of a thunderstorm follow the action, and towards the end, one of the few point-of-view shots in the scene aligns us with the Queen and opens up the possibility that our sympathies may fully shift to her. As she comes to the precipice and to the boulder she hopes will protect her, the angle shifts to her view of the club-wielding dwarfs scrambling up the mountain towards her. They are still Sleepy,

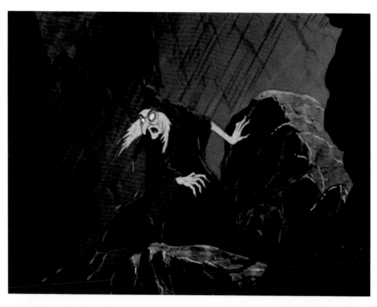

While they pursue her to her death, the dwarfs seem far more frightening than the witch

Bashful and Sneezy, although they look anything but, and instead resemble nothing so much as a lynch mob. At least in this one scene, a Disney fairy tale has become, for a few moments, a revenge fantasy straight out of one of Fritz Lang's Hollywood films from the period. The Queen may still frighten us here, but we are also frightened for her, and the memory of her death lingers longer than the glow of love's first kiss that follows soon after.

The songs

Most of us who have seen the film, regardless of the vivid impression made by the Queen, probably think of Snow White first in terms of its mode of production. We understand it as the model of the animated film, made up of thousands of celluloid paintings produced by hundreds of animators, inbetweeners, inkers, painters and others. But the film is also significant not just in the history of the fairy tale, or as one of the high points of Hollywood-era animation. It is also important as part of the history of one of Hollywood's central film genres. Snow White is a musical, and it appeared during a significant period in that genre's development. The songs in Snow White, by Disney stalwart Frank Churchill (he had written 'Who's Afraid of the Big Bad Wolf?' for The Three Little Pigs in 1933), take up an inordinate amount of screen time. Early on, Snow White's 'I'm Wishing for the One I Love' blends seamlessly into the Prince's 'One Love'. Just a few minutes later, after her banishment, Snow White sings 'With a Smile and a Song' to the forest animals around her. Shortly after that, she sings 'Whistle While You Work' as she cleans the dwarfs' cottage, and this number segues to two other songs about labour, the dwarfs' 'We Dig Dig Dig', which quickly transitions to 'Heigh-Ho'. This pattern continues throughout, rendering the narrative inseparable from the songs, and practically incomprehensible without them. ·

This dependence on songs to tell the story, on the music that links Snow White with the Prince at the beginning, or on 'Some Day My Prince Will Come' to explain her longing and desire, makes the

film an 'integrated musical'. Prior to the late 1920s, this form was virtually unknown in American popular culture. Stage musicals typically relied on a revue format, with more or less unrelated songs strung together by the merest hint of narrative. Or, the great musical stars of the day, Al Jolson for instance, simply stepped out of the stage stories and performed their own acts, acts that were far more important than the plays in which they appeared. There were some popular exceptions, of course – for example, the operettas of Franz Lehar (*The Merry Widow*) or Victor Herbert (*Naughty Marietta*) – but for the most part, the American musical stage of the early twentieth century tended to separate songs from narrative, and often forgot about narrative altogether.

Then, of course, composer Jerome Kern and lyricist Oscar Hammerstein II wrote *Show Boat*, which first played in New York in 1927. That musical, and its great international success, helped change the thinking about the genre and about the relationship of songs to narrative. Just a little over fifteen years later, another Hammerstein musical, *Oklahoma!*, this one written with composer Richard Rodgers, fully confirmed the shift in musical form, merging dance, music and narrative. In between the two stage musicals, however, movie musicals made the most significant development in the form. There were, of course, the great Busby Berkeley backstage musicals – *42nd Street* (1932), *Footlight Parade* (1933), *Gold Diggers of 1933* (1933) – which, with all of their visual virtuosity, were indebted to the tradition in which songs were unrelated to the film narrative. But there were others that combined music and story, so that, in *Love Me Tonight* (1932), 'The Son of a Gun Is Nothing but a Tailor' tells us everything we need to know about the snobbery of the Parisian aristocracy and the impossibility of Maurice Chevalier's romance with Jeannette MacDonald; while Cole Porter's 'Night and Day' charts the development of Ginger Rogers' feelings towards Fred Astaire in *The Gay Divorcee* (1934). And then, of course, there is *Snow White*, which probably more than any major film up to that time relied on songs to tell its story, to convey

character, motivation and plot to the audience. Disney's film forms an important link in the development of the genre that brings us, eventually, not just to *Oklahoma!* but to such operatically inflected musicals as *The Most Happy Fella* (Frank Loesser, 1956) and *West Side Story* (Leonard Bernstein, Stephen Sondheim and Arthur Laurents, 1957), as well as others by Sondheim and on up to such contemporary Disney stage musicals as *Beauty and the Beast* (Alan Menken, Howard Ashman and Tim Rice, 1994) and *The Lion King* (Tim Rice and Elton John, 1997).

As the voice of Snow White, Adriana Caselotti's wispy soprano sounds old-fashioned to contemporary audiences, but at the time it fully combined vocal elements from many of the popular and important singers in movies. Though not as rich, Caselotti's voice invokes the soprano of perhaps the greatest musical star of the period, Jeannette MacDonald. During the planning and production stages of *Snow White*, MacDonald appeared in a series of hits for MGM, with both Maurice Chevalier (*The Merry Widow*, 1934) and Nelson Eddy (*Naughty Marietta*, 1935, *Rose Marie*, 1937, and *Maytime*, 1937), and was undoubtedly in the greatest phase of a career that moved from Broadway to Hollywood to opera.

A far more improbable career than Jeannette MacDonald's was that of Grace Moore, the Metropolitan Opera star who became, for a few years at least – and at a critical time for the development of *Snow White* – a major movie star. Moore debuted in New York in 1928 as Mimi in *La Bohème*, and just a few years later, and with only three films behind her – *One Night of Love* (1934, for which she received a Best Actress Oscar nomination), *Love Me Forever* (1935) and *The King Steps Out* (1936) – she was one of Hollywood's most important leading ladies.[46] Her popularity declined significantly after that, and she made her last film in 1939, but in the mid-1930s her success proved that the sound of opera, and the pitch of the diva's voice, could bring a veneer of high art, always so important to Disney, to the movies without sacrificing a film's popularity.

The character of Snow White, of course, seems far less adult than the roles typically played by MacDonald or Moore, and her voice is clearly more adolescent. Her singing seems something of a combination of Deanna Durbin, the teenage operatic virtuoso whose popularity among young women, especially, was enormous at the time, and the more fully infantile voice of Shirley Temple, one of the greatest stars of the mid-1930s. But like so many of the Disney characters to come, Snow White (and perhaps in much the same manner as Temple) is not without sexual allure. In fact, in a likeness unavailable to audiences at the time of the film's initial release, and even more than invoking MacDonald's movie soprano or Moore's fully operatic vocals, her voice reminds us of the breathy thinness of Marilyn Monroe's singing in the 1950s.

Snow White marks the high point of the operatically inflected female voice in the movies. Other performers would sound like Caselotti or MacDonald – for instance, Kathryn Grayson, or the singers providing the voices for other Disney leading ladies. But by the late 1930s, the favoured female voice had changed, to something more in keeping with the popularity of the white pop and swing singers of the period. A movie from 1939, and one that is difficult to imagine had it not been for the popularity of *Snow White* as a fantasy, fairy-tale musical, exemplifies the shift. When MGM chose Judy Garland to star in *The Wizard of Oz*, they selected a performer who, like Snow White, hovered somewhere between adolescence and adulthood. But they also selected the performer who would become one of the era's great popular singers, whose contemporary, jazzier style marked the decline, in popular culture, of MacDonald, Moore, Durbin and also Caselotti.

The visual style

The multiplane camera used in so many scenes in *Snow White* produced an in-depth visual space that marked a complete departure from the flat canvas of most cartoons, as well as from the compressed depth of almost all Hollywood films of the time. The film produced

its apparent reality effect not only from the movement of characters across a screen on which even the smallest element – a quivering leaf – was drawn in slavish detail, but because viewers themselves could discern levels seemingly from the front to the back of the screen. *Snow White* might seem like a visual oddity to us now, because the multiplane camera never fully caught on as an industry standard and, within fifteen years, cartoon aesthetics – even in many Disney films – moved towards the more limited animation of the UPA Studio as well as that of television cartoons. But the film's claim to realism fully corresponded to the arguments about depth and space that were current at the time and would persist for at least the next two decades, arguments that French film theorist André Bazin would soon be making about the depth-of-field realism of the live-action films of William Wyler and Orson Welles, in which action in the deep background seemed as clear and compelling as that in the foreground.

Precisely because they felt constrained by the necessary flatness of cartoon space – animated films had, after all, evolved from drawings on paper in the early years of cinema to painted sheets of celluloid – animators had experimented for a number of years with adding the appearance of depth to their films. They accomplished this with the drawings themselves, using the classical rules of perspective to provide a sense of deep space and three dimensions. But it was also facilitated by the cameras they used. The great German silhouette animator Lotte Reiniger designed a multiplane camera in the 1920s, and the Fleischer Brothers – who produced *Betty Boop* and *Popeye* cartoons for Paramount – used one in the 1930s. Ub Iwerks, the animator so important to Disney's initial success (and who left the company in the early 1930s to open his own cartoon studio), made significant advances in the multiplane, advances that led directly to the Disney model used on *Snow White*.

The Disney multiplane was a technological marvel. Technicians mounted a camera on a scaffold about ten feet high. That camera then looked straight down through as many as six glass planes.

Each plane was decorated with one level of a scene's background and could move horizontally as well as vertically, in relation to each other as well as to the camera. When filmed, this combination of moving, two-dimensional planes gave the sensation of three-dimensional space. As Disney himself explained in a 1957 promotional film about the studio's technological achievements, in standard animation, photographed on a single two-dimensional surface, a camera might move in or out to make images seem larger or smaller. He used the example of a moonlit farm scene. As the camera moved in, 'you'll notice', Disney said, 'that everything grows larger, including the moon'. He then added, 'Now, when you walk along a country road toward the moon it certainly doesn't grow larger … nor does it shrink in size when you walk away from it. The problem was how to take a painting and make it behave like a real piece of scenery under the camera.' The multiplane solved this problem of relations between different elements in a scene, so that an image of the moon, on a

In a 1957 promotional film, Disney explains the multiplane camera that had been so important to the look of *Snow White*

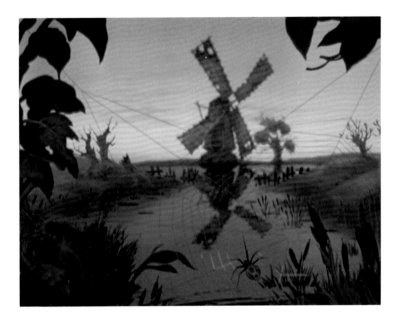

separate plane from an image of a farmhouse, would remain the same size even as the farmhouse apparently became larger or smaller, depending on the movement of the camera.

Even while *Snow White* was in production, Disney experimented with the multiplane in other films. In November 1937, he released *The Old Mill*, a cartoon in the *Silly Symphonies* series and the film that introduced the new technology to the public. Given the extended use of the multiplane in this short, *The Old Mill* may be an even more remarkable film, visually, than *Snow White*, which highlights the new camera more sparingly. *The Old Mill* tells the wordless story of a storm and the threat it poses to the animals living in and around the mill, and especially to a nesting bird hatching her eggs there. The first two minutes – a significant amount of time in a cartoon just a little over eight minutes long – rely almost exclusively on the multiplane, and show off everything the camera can do. In the opening shot, we see a spider on a web in the very near foreground

In *The Old Mill*, which premiered a month before *Snow White*, Disney experimented with the depth-of-field effects of the multiplane camera

and the much smaller mill deep in the back; gradually, via a series of dissolves, the camera moves through the web and towards the mill, always maintaining proper relations between objects near the camera, somewhat removed from it and far away. Once inside the mill, the camera pans up, past different birds roosting there, to the bats hanging upside down, and again, even in this confined interior space, the film creates a significant illusion of depth. In just this opening thirty-second introduction to the setting of the film, until the brief return of 'flat animation' during the scene of the recital of the croaking frogs and chirping crickets, the multiplane has shown its virtuosity. Disney's new camera can seemingly move into a scene and also laterally (the multiplane itself typically did not budge; rather it was the glass planes that moved), always maintaining the correct spatial relationships between objects in the scene and between viewers and those objects.

The film won Disney yet another Academy Award for Best Cartoon, and *The Old Mill* played prominently, and for extended runs, in many cinemas. In New York, for instance, it played on the same bill as *I'll Take Romance*, a prestige film with opera star Grace Moore and Melvyn Douglas at Radio City Music Hall. The cartoon appeared there for several weeks as part of a Christmas extravaganza, with a live 'pageant of the Nativity' and music from a symphony orchestra.[47] There is evidence, however, that *The Old Mill* may have been more of an artistic accomplishment than a popular one. A syndicated profile of Disney from 1938 called 'The Father of Snow White', and one that was almost certainly approved by the Disney Studio, acknowledged that not all of the cartoons 'click', and that 'there was one called *The Old Mill* about which all the boys [at the studio] are still sheepish'.[48] Nevertheless, the film demonstrated the possibilities of the multiplane, and prepared audiences for the astonishing success, both artistic and popular, of the feature film to come.

Disney and his animators made *Snow White* into a case study of virtuoso animation visual style. The film opens with the camera

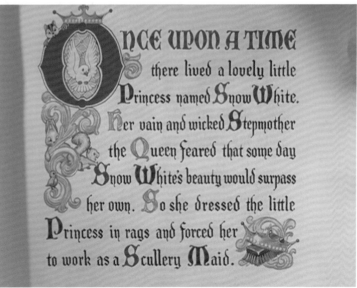

ONCE UPON A TIME there lived a lovely little Princess named Snow White. Her vain and wicked Stepmother the Queen feared that some day Snow White's beauty would surpass her own. So she dressed the little Princess in rags and forced her to work as a Scullery Maid.

The book that opens the film, and then the first page of the story

pulling into a book entitled *Snow White and the Seven Dwarfs*, and then dissolves to the first page, which introduces us to the Evil Queen and her stepdaughter, Snow White, and to the Queen's insistence on being 'the fairest one of all'. After a fadeout, the castle appears in the background, and the film replicates the opening of *The Old Mill* as the multiplane camera, through a series of dissolves, moves into the Queen's chamber. Once inside, the animation becomes, at least in relative terms to the multiplane effects of the opening, 'flat'. But even here the film works to produce a full sense of deep space, as we see from the back, and from a distance, the Queen as she looks into the full-length mirror. We see her reflection there, and then the film cuts to a closer shot of that reflection within the mirror. She calls to the 'slave in the magic mirror … through wind and darkness', as fire, wind and lightning appear in the mirror. The face of the slave emerges, deep in the background of the mirror, with smoke billowing in the foreground, as the Queen asks for reassurance that she is still the 'fairest'. Every shot in this opening, whether making full use of the multiplane or filmed more conventionally, produces the sense of extended space. When the camera dissolves into the castle, we always know where the castle stands in relation to the rest of the landscape, whether or not we can see the trees or mountains of a previous shot. When we see the Queen's reflection in the mirror, we also have a sense of the Queen, offscreen, standing directly in front of the mirror. When we see the slave in the mirror, the smoke that obscures him, along with the Queen's offscreen voice, creates an effect of deep space both within and in front of the mirror.

These opening shots – just a few minutes of screen time – set the tone for the visual quality of the rest of the film. As the mirror proclaims that she can no longer be considered the fairest, the Queen, fully understanding the competition, exclaims, 'Snow White!' The name motivates a cut to Snow White herself, scrubbing stairs in the castle. The animation here makes less obvious use of the multiplane, but this does not prevent a wonderful interplay of foreground and background. When Snow White goes to the well, she

As the multiplane camera takes us closer and closer to the castle and then into the Queen's chamber, we see the Queen's reflection in the mirror, and then the slave in the mirror speaking to the Queen

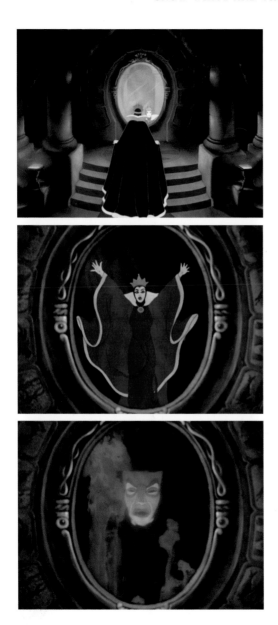

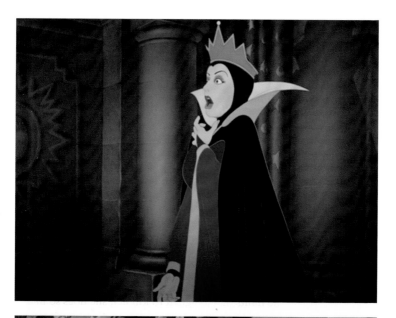

As she listens to the mirror, the Queen realises that Snow White is now the fairest in the land. The scene then shifts immediately to Snow White as palace scullery maid

walks behind a tree which, taking up almost the entire foreground, makes the viewer aware of the dimensionality of the artwork. At the well itself, she is partially obscured by the columns that support it. As she sings 'I'm Wishing for the One I Love', the Prince rides towards the castle. In a deep multiplane effect, he enters the frame from the far background and the camera follows him laterally to the near foreground, with trees, rocks and the stone walls of the castle nearest to the camera. The action returns to Snow White. She looks into the well and then, from her own point of view, we see her reflection in the water. This shot 'rhymes' with the one of the Queen looking in the mirror, and likewise did not require the multiplane. But Snow White's reflection towards the back of the frame, the classical perspective of the shot and the concentric circles of water billowing from the reflection make this one of the most striking moments in the film, and one that creates an astonishing illusion of space and depth.

Similar examples appear throughout the film. When Snow White walks past the huntsman assigned to kill her, she does so in a multiplane shot that emphasises the extraordinary capacity of Disney's camera to produce dimensionality. Then, she kneels in front of a rock and picks up a baby bird that has lost its parents. The animation here has been done conventionally. But Snow White is positioned in the middle of the frame, her shadow falling on the rock in front of her. The bird flies from her hand off the upper left side of the screen and the huntsman's shadow looms onto the rock from the lower right, letting us know, along with Snow White's frightened look offscreen in that direction, that he is here to kill her. The interplay of shadows and looks, as well as the action, across a diagonal line, from upper left of the screen to lower right, creates a sense of deep space within the frame and of the spaces beyond it, a visual effect requiring no special apparatus, but only the immense skill of the animators.

The huntsman, of course, cannot kill Snow White, and instead urges her to run away. Frightened, she takes off through the forest, and here the interaction of depth and flatness produces some of the nightmare imagery that haunted so many young viewers of the film

Snow White walks to the well in one of the film's early multiplane effects. Then she looks into the well, and sees her reflection

over the decades. Her flight through the forest shows off the multiplane to great effect, as she moves into and away from the camera, with alligators pursuing her, bats flying in front and back of her, and tree limbs blocking her path, the camera following her lateral movements. But we also see, from her point of view, absolutely still images of unidentifiable forest monsters, monsters that invoke nothing so much as William Blake's etchings for Dante's *Inferno* or for some of his own poems. The camera zooms in, which only accentuates their horrible stillness. This switching back and forth between movement and dimension within the frame, and then movement only by the camera onto a single image, makes Snow White's fear palpable, and gives a sense of fully vertiginous animated space.

Its spatial richness links *Snow White* to many of the important live-action films of the period, to the visuals of such directors as John Ford, Rouben Mamoulian and Josef von Sternberg in Hollywood, or

The huntsman's shadow, and Snow White's look offscreen, provides a sense of space beyond the limits of the frame

Snow White begins her escape through the forest, becomes entangled in the trees as she runs away from the huntsman and encounters a series of monstrous images and animals

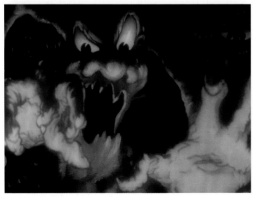

Jean Renoir and Max Ophüls in France. Indeed, with the extraordinary depth achieved by the multiplane camera, the film even exceeded the spatial extravagance of the work of those directors. Also, the visual quality of the film, as well as its aural dimension, made *Snow White* a new kind of genre film, one that Disney would develop more fully a few years later with *Fantasia*, and then continue to work on with more minor films such as *The Three Caballeros* and *Make Mine Music* (1946).

Indeed, with scenes like Snow White's terrified escape through the forest, the movie seems as much an avant-garde film as a standard Hollywood narrative. And of course while the film is a musical, it is also a romantic melodrama, thus linking it to the woman's film and other similar forms that had been popular in movies for decades. The mixture of fantasy and realist elements, something that had long been important to the fairy tale as a literary product, also connected the film to such silent experiments as the *Thief of Bagdad* (1924). Before *Snow White*, however, sound films had been unable to make the two come together cohesively (as the box-office failure of Paramount's live-action *Alice in Wonderland*, from 1935, demonstrated).

Colour

The colour palette used by Disney's animators contributes to the film's sense of dimensionality and fullness practically as much as the multiplane camera. And as a result, *Snow White* fulfilled much of the promise of the new three-colour process that Technicolor had introduced in 1932. An earlier two-colour process recorded only those colours on the red and green scale, which resulted in such impressive but still somewhat ghostly and washed-out films as *The Toll of the Sea* (1922), a silent retelling of *Madame Butterfly* that helped make Anna May Wong a star. Technicolor's new system added blue to the process, providing a range of colours that seemed much more realistic. With its requirement for a special camera that held three strips of film, three-colour Technicolor was viewed with caution by the major film studios, which were wary of the added

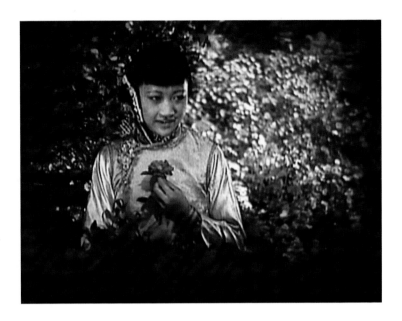

expense of the extra film and the new equipment, especially after the
cost of their rapid conversion to sound. Disney, however, moved to
colour enthusiastically, and his *Silly Symphonies* of this period, and
then *Snow White*, helped establish the 'look' of the Hollywood
Technicolor film.

Colour films made before the three-colour system, and even
some of those made with the new process, were often criticised for
their artificiality. But Disney sought to use colour to establish the
realist effect of his films. He wanted both sound and colour to
contribute to narrative and character. Backgrounds, for instance,
should be coordinated with the colour schemes associated with the
central characters and must not detract from the foreground action.
Also, colours needed to contribute to the illusion of space in Disney's
cartoons: as Richard Neupert has pointed out in his work on Disney
animation, 'cooler colors and tints tend to recede, while warmer
colors and shades appear to advance'. Bright colours appeared to be

The muted colours of two-colour Technicolor; Anna May Wong in *Toll of the Sea* (1922)

larger than dark hues, with strategically placed shades thereby improving the perception of depth in any single image.[49]

From the very first shot of *Snow White*, audiences knew that they were in for a special visual experience. As the book opens to begin the tale, we see a page that is less important for what it says – after all, most viewers know the story – than what it shows. An exquisitely illuminated manuscript begins with a bright-red 'Once upon a time', a golden crown surmounting the oversized capital 'O', with gold filigree below. All capital letters on the white page are deep blue, red or gold, and the last words on the page, 'Scullery Maid', identifying Snow White's servitude to the Queen, are illustrated by a red scrubbing brush decorated with the same golden filigree of the opening text. The vivid tints both attract our attention and inform us, and the pleasure of this opening and of the movie to follow derives largely from the beauty and tone of the colours. Clearly, then, we are being prepared for an experience where colour, literally, tells the story.

The scene then dissolves to the series of shots that bring us closer to, and finally inside, the Queen's castle. The watercolour greens of trees frame the castle, drawing our attention to it, while the blue-green lake below, blue sky and puffy white clouds above also serve to focus our attention on the white palace perched on a hilltop. But then we come to the Queen's chamber, and the colour palette changes. The room is dark, and the Queen appears in a black cape with white trim and deep-purple lining, a blue dress, and a gold crown and necklace. Her lips are lushly red and her skin solid white, except for reddish cheeks; this skin, these cheeks and those lips will be the visual links between the Queen and Snow White, who has precisely the same colouring. When the Queen looks in the mirror, the reflection is illuminated by white flashes of lightning and a golden fire with pink highlights, as the indistinct, shadowy face emerges in the mirror's background to answer her question about the fairest of them all.

There is no conclusive evidence, but the vibrant colours associated with the Queen, and what can best be called her

extraordinary sense of style and colour combination, almost certainly contribute to the deep impression that she has made on so many viewers, especially children, and to her capacity to frighten and fascinate audiences. Nothing else in the film matches these intense colours, and Disney and his animators certainly had it in mind that the deep, rich hues would differentiate the Queen from the other characters, emphasising her wickedness in the face of their goodness. When the scene shifts from the castle to Snow White scrubbing the palace steps, the changes in colour and tone clearly indicate that we have entered a different world.

With the entrance of Snow White, we leave the bold, primary Technicolor space of the Queen's chamber for something much more reminiscent of the refined tradition of the European watercolour. Indeed, our first view of the Princess is a washed-out disappointment after the scene in the Queen's chamber, with soft-white doves, greyish-brown stones and pale-lavender flowers that match Snow White's dress and bodice. The shadows and gradations of colour are exquisite but hardly memorable, and if Snow White seems boring to viewers now in comparison to the Queen, it may well be not only because of her conventional goodness but also the colours that introduce her, and that, with some variation, follow her throughout the movie.

Not until the first brief appearance by the Prince, with his deep-blue tunic, dark-brown cape and the red sash adorning his white horse, does intense colour return to the film. After the Prince's short meeting with Snow White, the scene moves back to the Queen's chamber, and to the colours that so focused our attention at the start of the movie. As she orders the huntsman to kill Snow White, the Queen sits on a throne embossed with blue, gold and white peacock feathers, an ostentation seemingly designed to emphasise her vanity and also the capacity of Technicolor to depict intense hues.

The film then returns to a watercolour exterior, where we see Snow White in the outfit that has become so familiar to us: the high white collar, black cape with red lining, blue bodice and yellow dress.

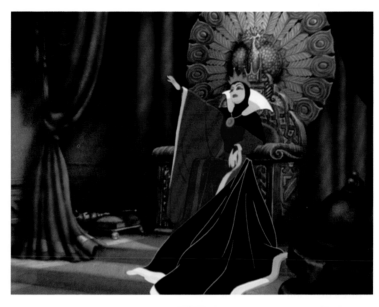

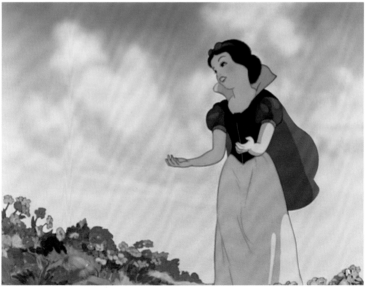

The Queen, in her peacock feather-style throne; Snow White, in her usual outfit

For the first time, we are treated to the interplay of Technicolor vibrancy and a lighter, more subdued background palette, which Disney's team of animators then uses throughout the film to call attention to objects, animals and people. To take just one example from many, consider the moment, much later in the film, after Snow White has cleaned the dwarfs' home and is about to go to sleep. Against the light browns of the walls and cupboards, and in close-up, a bright-blue bird with an orange beak uses her tail feathers to put out a yellow candle flame. We might be dimly aware of the beautifully carved design of a rabbit on the shelf at the left of the frame, or somewhat drawn to the indistinct edge of the wall diagonally off to the right. But the force of the colours draws our eye to the bird and the candlelight, and to a typically cute Disney joke – putting one's rear end to functional use.

For the most part, though, the film counters the softness of the hues associated with Snow White with the high-intensity colours of

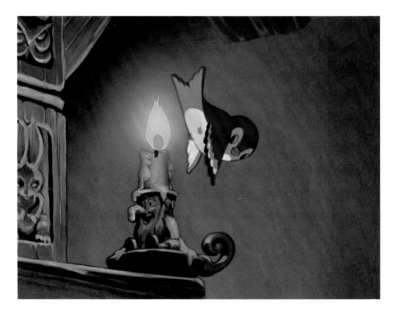

A little bird in the dwarfs' cottage finds a convenient way to put out a candle

the Queen. Snow White's chaotic flight through the forest stands out as one of the high points of early three-colour Technicolor, with its use of blacks and whites in ways unthinkable in standard film, and characterised by colours almost never seen in any movie before *Snow White*. The forest is deep blue and dark black, making Snow White's yellow dress resemble a flash of lightning, or the small white eyes of an owl appear more ominous than those of any predator. When monstrous yellow, orange and white eyes against a black background menace Snow White, the film reaches a level of abstraction rarely seen in a narrative film from the sound era, seemingly imparting colour to the black-and-white expressionist experiments of German director F. W. Murnau during the silent period. If the Technicolor Queen hadn't frightened the children in the audience by this point, then the forest sequence – where bright colours make everything seem visible, just as the black backgrounds make everything indistinct – certainly did the trick.

The seven dwarfs inhabit their own sphere of colour. They first appear in the mine, digging for diamonds. The mine, of course, is dark, but the dwarfs are bathed in the light reflected off the bright-white diamonds shining around them. And while colours both link and separate the Queen and Snow White – their black capes, red cheeks and lips, but also the heightened Technicolor of the former and the washed-out watercolours of the latter – the dwarfs find themselves fully identified by colour. Disney wanted the dwarfs to have separate personalities, which resulted, for instance, in Grumpy and Bashful and the silent Dopey. But each one also wears a different colour combination: Doc in red tunic, mauve trousers and green hat; Sneezy in wine-coloured trousers, deep-grey top and burnt-orange hat; Grumpy in a lavender shirt; and Dopey in purple hat, green tunic and blue trousers. Except for Dopey (and different facial expressions notwithstanding), they all look more or less alike with their long white beards, so the colours of their clothes give viewers important cues about just which dwarf is which.

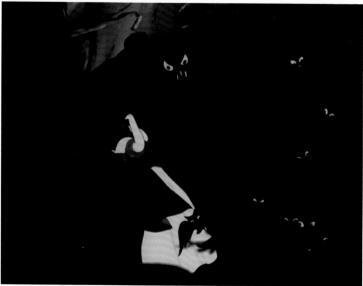

The dark forest contrasts with the Technicolor palette of the rest of the film, and also with Snow White's own clothes

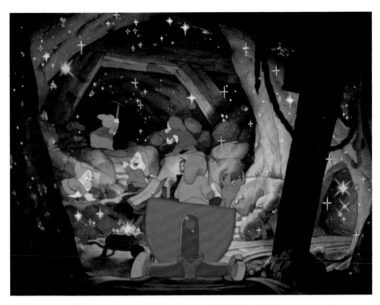

The glistening diamonds light the mine where the dwarfs work; As they did with all
the dwarfs, Disney's artists provided Dopey with a distinctive colour pattern

Performance

In *Snow White*, Disney and his animators designed a colour palette that accomplished a range of tasks. Colours acclimatised us to the spaces of the film and guided our eyes to the important spaces within frames. Colour let us understand the linkages between the two central characters of the film, the Queen and Snow White, and also to the differences between them, and in doing so almost certainly contributed to the decades-long fascination with the Queen herself. And even while contributing to the nightmares of children everywhere, the colours also, and in the most mundane terms, helped us differentiate Grumpy from Bashful from Sneezy, and the three of them from Doc, Happy and Sleepy.

By the time he made *Snow White*, Disney was well known for the distinct characters in his cartoons. He had used costumes to indicate character before, and clothes often functioned as important shorthand for personality traits in his cartoons, affording an immediate identification so important in films lasting only seven or eight minutes. In *The Three Little Pigs*, Disney's most celebrated movie before *Snow White*, the two frivolous pigs wear blue-and-black sailor tops and caps and no trousers (in the tradition of so many Disney characters), while the fully clothed serious pig (who builds his house out of brick) wears overalls, white gloves to keep the cement off his hands, and a white cap.

Cartoon characters possessed well-defined character traits before Disney became the gold standard in animation. Betty Boop, for instance, showcased a range of traits that were no narrower than some established, live-action Hollywood stars. But by the early to mid-1930s, Mickey Mouse and Donald Duck, in their individual series of films, as well as Goofy, who developed over several years from Dippy Dawg to the character we still know today, also established recognisable screen personas, as the Three Pigs had done in just their first film.

By about the time of *Snow White*, however, Mickey's character had begun to flatten out, and Mickey himself appeared in fewer and

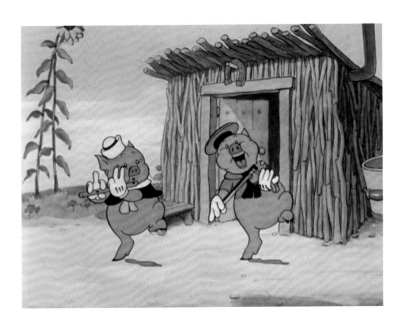

fewer films. He turned up, of course, in featured segments in *Fantasia* ('The Sorcerer's Apprentice') and the 1947 feature *Fun and Fancy Free* ('Mickey and the Beanstalk'), but even in these limited appearances, Mickey's status as an internationally beloved icon made it difficult for him to engage in the full range of behaviour – violence, sneakiness, etc. – that marked his earlier films. By the late 1930s, only Donald Duck among the major Disney stars maintained any compelling personality tics and traits.

Snow White highlights some of the problems apparent in Mickey's films from the time. Aside from the distinctive colours of their costumes and acting in accordance with their names, the dwarfs, in general, seem very similar, while the performances of the animated figures and their human voices lack much of the nuance one might expect from a feature-length movie. The dwarfs' relentless and violent pursuit of the Queen, at the end of the film, stands out as a welcome, and fully motivated, development in their characters, but

Before *Snow White*, Disney most famously used colour to differentiate characters in *The Three Little Pigs* (1933)

after her death they are soon reduced, once again, to solemn devotion to Snow White, this time to her corpse in the glass casket.

We find the same problem in many of the characters. The Prince, who turns up only now and then in the film, remains a cipher. Snow White, for all of her screen time, is hardly more interesting, and she sets the template for most of the Disney princesses for decades to come: adolescent, uncurious, passive. Her songs tell us broadly of her outlook and desires, about whistling while she works and hoping that someday she will find her prince. But with little else to go on besides the songs – there is scant dialogue in the film – audiences are left with a disappointingly under-developed main character.

The one significant character who does not sing – the Queen – stands out as the only really compelling personality in the film. She is driven by human emotions writ large: jealousy, hatred, narcissism, insecurity. She is also subject to an extraordinarily violent death when, as the old hag and pursued by the dwarfs, she plummets off a cliff. Unlike Snow White, the Queen seems fully adult. Lucille La Verne, who supplied the Queen's voice, and in contrast to Snow White's Adriana Caselotti, had been performing in movies – mostly in very small parts – for years, at least since 1915. At the time of the film's production, La Verne was well into her sixties (she was sixty-five in 1937 when the film was released; Caselotti was twenty-one). As a result, the Queen, both as drawn and in the timbre of her voice, strikes audiences as a mature woman, with the weight of emotional experience behind her.

Disney and his animators seemed to understand this, and to have a special interest in the character. They lavished attention on the Queen's transformation into a hag, as she carefully itemises the various elements in the concoction she blends: the mummy dust that makes her old; the black of night that shrouds her clothes; the old hag's cackle to age her voice; the scream of fright to whiten her hair; the blast of wind to fan her hatred; and the thunderbolt to mix it well. After she swallows the potion, the Queen can barely breathe as the camera seems to whirl around her, a riveting performance of physical

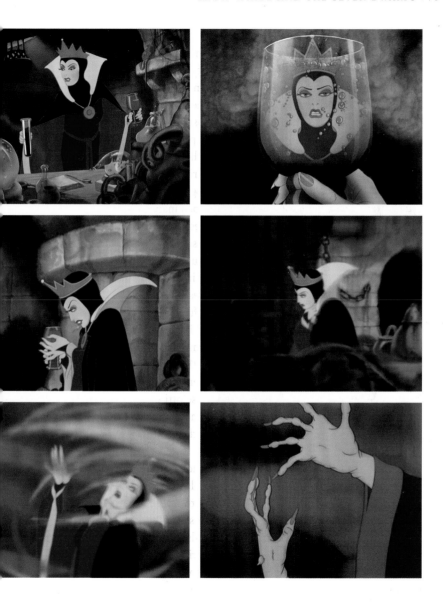

Animators lavished attention on the Queen's transformation into the witch, from mixing the ingredients, to drinking the fluid, to the gnarled hands that were the result

violence in what is, after all, a cartoon meant largely for children.
As the Queen witnesses her own transformation, La Verne invests her
with equal parts of pleasure and horror: 'Look! My hands!' she
exclaims, as she watches her delicate fingers and palms turn old and
gnarled, resembling something like an early version of Norma
Desmond in *Sunset Boulevard* (1950), mourning her passing beauty.

It is perhaps this scene of transformation that children have
found the most frightening: the violent shift from youth to age, from
beauty to ugliness, a transformation that almost kills the Queen
immediately and then leads to her death at the end of the film. At the
very least, this scene and others in which she appears make the Queen
the most memorable character in the film, while the nuances of La
Verne's performance also, perhaps, make her the most sympathetic.
The audience wants Snow White to live. But the Queen makes a
convincing case for wanting her dead, and it is difficult always to
root against her.

Influence

With *Snow White*, Disney seemed to have developed a new form of
film-making, one that combined the forms and styles of so many
different kinds of production. Rather than creating something unique
to the animated film, Disney had produced a movie that would have
a significant impact on live-action production for years. Coming two
years after *Snow White*, *The Wizard of Oz*, with its heightened
colour palette, its combination of fantasy and drama, and songs that
rounded out a fairy-tale story, would be unthinkable without
Disney's film. Michael Powell's opulent experiments in visual
technique and genre in the UK – *The Red Shoes* (1948) or *A Matter
of Life and Death* (1946) – similarly owe more to *Snow White* than
to any other Hollywood film. Even Orson Welles, the man who
would take Disney's place as Hollywood's resident genius once
Disney's own reputation began its gradual decline in the early 1940s,
owed a debt to the animator. While their styles and temperaments
seem quite different – from the sentiment of Disney to the irony of

Welles – their films have significant similarities. Welles famously said that, to prepare for his first film, *Citizen Kane* (1941), he watched John Ford's *Stagecoach* (1939) over and over, and from that film began to understand some of the possibilities of the deep focus for which he and his cinematographer Gregg Toland became known. But he may just as well have watched *Snow White*, as few Hollywood films seem to prefigure the spatial density of *Kane* as much as Disney's first animated feature, with its fluid use of the multiplane camera. The stylistic importance of *Snow White*, the impact of its combination of genres, its use of music and its visual developments may well have been less influential in animation – few cartoon studios could hope to match Disney's films – and much more significant, for decades to come, in the live-action feature films made in Hollywood and Europe.

4 The Response

Los Angeles

When the dust settled from that extraordinary premiere covered coast-to-coast by radio, where celebrities like Barbara Stanwyck, Spencer Tracy, Ginger Rogers, Frank Capra and Ernst Lubitsch paid as much as $5 for a ticket, *Snow White* began a spectacular run in Los Angeles. The film opened at the city's opulent Carthay Circle cinema, and showed only twice daily, at 2:30 in the afternoon and 9:30 at night. The Carthay seated 1,500 viewers, and sold all seats for *Snow White* on a reserve basis, from 50 cents up to $1.50.[50]

In his film review for the *Los Angeles Times*, Edwin Schallert proclaimed that 'True poetry has been achieved in this first super production.'[51] But movie fans in LA had the chance to see any number of terrific films the week that *Snow White* opened. *The Life of Emile Zola*, with Paul Muni, drew enthusiastic crowds, as did *Rosalie*, with Jeannette MacDonald, and *Wells Fargo*, with Joel McCrea. *Snow White* made $19,000 that first week, far above the weekly average for the Carthay Circle (not quite $12,000), and a higher return than any other cinema, but only marginally so (*Zola*, for instance, made $17,000, although it was certainly not unusual for first-run films to make far less than that).

The really remarkable record of this opening run developed from week to week, as *Snow White* continued to draw large crowds into the Carthay Circle; more in the second week than in the first, and then subsequent receipts that barely declined – from $14,000 in its third week to $12,600 in its sixth and $12,500 in its eighth. This kind of box-office performance meant that *Snow White* constantly attracted new audiences, and also that viewers went to see it again and again. A few weeks after this West Coast premiere, however, *Snow White* opened in New York, at the lavish Radio City Music

Hall, and it was here (and subsequently, following its nationwide release) that Disney's film turned into a cultural event. In its first full year of domestic and then international release, *Snow White* emerged as a phenomenon that the industry had rarely seen since the conversion to sound began ten years earlier.[52]

New York

Radio City held 6,200 viewers, more than any other cinema in the country, and the fans of *Snow White* filled it week after week. The film made $110,000 in its first week there, almost twice the total of the next highest grossing film, *Every Day's a Holiday*, at the Paramount cinema, which had the benefit of Benny Goodman and his orchestra appearing on stage, and far more than the $30,000 earned by Spencer Tracy and Joan Crawford in *Mannequin*, at the Capitol. From week to week, the numbers remained unchanged: in its fifth week at Radio City, *Snow White* grossed $100,000, and had been seen, overall, by 800,000 New Yorkers.[53]

These staggering returns seemed to require an explanation of scientific clarity. The *Motion Picture Herald*, the trade journal of choice among cinema owners at the time, ran a cover story on '*Snow White* at the Box Office', charting daily attendance for weekend and weekday shows, and noting the weather for each day – snow, rain, fair or cloudy. As might be expected, *Snow White* drew its largest audiences on Saturdays and Sundays, although weekday viewings remained high, while meteorological changes had virtually no impact on attendance (20,000 people saw *Snow White* on a snowy Monday on 31 January, for example).[54] Prominent retail outlets did their best to take advantage of the *Snow White* craze in New York. Saks Fifth Avenue, for instance, understood that its high-class clientele felt the same as everyone else about the film, and devoted six of its store windows to illuminated scenes from the movie, each one 'framed in a reproduction of the [Radio City] Music Hall proscenium arch'. Even religious institutions got into the act. The Broadway Temple Methodist Episcopal Church staged a performance of *Snow White* 'enacted by kiddies of the

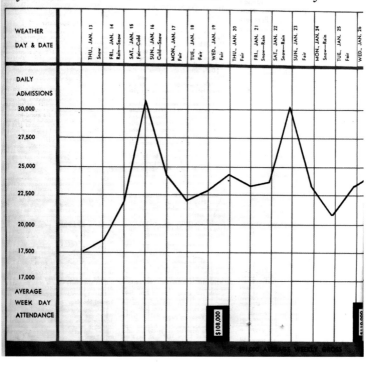

Results of the First Box Office Test Of "Snow White and the Seven Dwarfs"

congregation', followed by a sermon on the movie preached by the pastor, in which he 'urged his parishioners to see the film'.[55]

The national audience

When *Snow White* left its exclusive LA and New York showings and began opening across the country in February 1938, its astonishing popularity seemed only to grow. The film set records in Boston, required midnight showings in Oklahoma to meet audience demand,

A page from the *Motion Picture Herald*'s study of the remarkable attendance pattern for *Snow White* in New York (12 February 1938)

broke attendance records in Pinehurst, North Carolina, and literally appealed to all ages at the Knickerbocker Theater in Nashville, where newspapers ran photographs of two patrons – one nine years old, the other ninety-one – standing in line to see the movie. Before this particular screening, the governor of Tennessee paraded with the seven dwarfs from the state capitol to the cinema, which sold all of its first-day tickets within eight minutes of opening the box office.[56]

The film even produced something of a riot among fans in Baltimore trying to get in to the Hippodrome cinema. The police had to be called to the cinema during the film's first week there, and 'the throng at one time was out of control for four hours', after which 'clothing, hats, gloves and jewelry were found in the street'.[57] Overheated accounts like this one provide some of the extreme examples of fan behaviour around *Snow White*. But the best indications of the responses to the film of typical viewers come from

The governor of Tennessee paraded with the seven dwarfs when *Snow White* opened in Nashville (*Motion Picture Herald*, 12 March 1938)

more measured sources, and still indicate the extraordinary relationship between audiences and Disney's movie.

Every week, the *Motion Picture Herald* published a column called 'What the Picture Did for Me'. For this column, exhibitors themselves wrote in to discuss their clientele's responses to the films they showed, creating a sort of guide for cinema owners and managers about what to expect at the box office, or how best to publicise a film. Entries typically remained terse and to the point. But for *Snow White*, these usually hard-boiled exhibitors, almost all of whom owned independent, small-town cinemas with no connections to the large chains affiliated with the major studios, were effusive in their praise for the film, and in their discussions of audience response. These same exhibitors, however, also give us the terms for criticising *Snow White*, criticisms that never quite made their way into other media reporting on the film.

From the Rialto Theater in Paynesville, Minnesota, one exhibitor exclaimed, 'This is too great a picture to be able to do justice to in words', writing that 'people from miles around drove up to see it', and then 'talked it up to their friends, who came the next night'. From the Oriental Theater in Beaver City, Nebraska, another exhibitor wrote, 'Hats off to Walt Disney. Here is positively the grandest thing ever offered the public for entertainment.' Analysing the reasons for his audience's response to the film, he claimed that 'it appeals to every living person from the ages of 2 to 102, is flawless in its makeup and so real as to almost make the characters human'. An exhibitor from Groveton, Texas, told the *Herald* that the picture did wonderful business, with many coming to see the film a second time.[58]

Exhibitors sent this same kind of praise to the *Herald* again and again: *Snow White* broke all attendance records; word of mouth brought even more viewers to the film; many viewers saw the film more than once; this film proves Disney's genius. But the uniqueness of the film also produced problems, problems that exposed the hierarchies of the film industry and the lowly place of independent cinemas within it.

Even as they praised Disney for making the film, many exhibitors resented his business tactics, and those of his distributor

RKO. The studio and Disney insisted that cinemas hand over a full 50 per cent of all receipts, far higher than the usual rental charge. Making matters worse, RKO and Disney insisted that *Snow White* play by itself, and never as part of a double bill, so that exhibitors were unable to produce revenue from the friendlier terms connected to the second film.[59] The owner of the Strand Theater in Milford, Iowa, expressed outrage that he had to 'give any producer 50 per cent of the take', which left him with practically nothing after he had paid all of his expenses. That same exhibitor from Groveton who had extolled the virtues of the film also thought that 'Walt Disney should have given us a break so we could have made something out of it ourself [*sic*]', while another, after calling Disney a 'creative genius', wrote somewhat ruefully that 'credit must also be given to the inventive mind who was able to conceive the 50% category on film rentals'. For him and others, these terms meant that 'Walt Disney and RKO had the best part of it', leaving the exhibitors themselves with very little to show for having screened a bona fide cultural phenomenon. This same exhibitor lamented that he could have done just as well with 'a satisfactory western feature', a low-budget horse opera that, in the 1930s, represented the polar opposite of Disney's masterpiece.[60]

Other criticisms focused on how the intense interest in the film had actually harmed the box office in some cinemas. One Kansas exhibitor who showed the film in late spring 1938, and claimed to have lost money on it, complained that 'unless played first showing within a radius of 50 miles [*Snow White*] will lay an egg, as everyone who wants to see it will drive that far'. Another said frankly, 'we played this too late', in the summer of 1938, and added that 'many of our customers went to other towns to see it'.[61] During the 1930s, a Hollywood film might take the better part of a year to make its way across the country, and distribution patterns remained systematic. Once films left their first-run locations, they would go out to well-defined geographical areas, where audiences remained predictable and based most of their filmgoing activities within the neighbourhoods where they lived. The evidence for *Snow White* indicates that people

did not want to wait for the film to come to them. Instead, they left their neighbourhoods and even their towns to see the film, disturbing the systematic logic of Hollywood distribution.

The response to *Snow White* during its first year of release of course gives us a sense of what viewers thought about the movie, but also how Disney's film entered into the flow of daily affairs, how the film became a cultural event. The movie seems to have been an important topic of conversation, and it certainly affected how and when people went to the movies, and how far they were willing to travel to do so. Even if the public avoided the cinema, the film was a hard one to miss, with the store windows, parades and other public events devoted to it. Households certainly had their fill of *Snow White* artifacts – dolls, books, sheet music, records, glassware – through the fifty official licensees making merchandise connected to the film. Fans also made unofficial, unlicensed use of the film, adapting it to their own interests. In one report from 1938 that typifies so many of them, high school and college students had begun a dance craze called 'Doin' the Dopey', based on the loose-limbed, looping movements of one of the most popular characters in Disney's film.[62]

Blanche-Neige in Paris

Some of these responses – getting in the car to drive a long way to see a film, or college kids making up a dance – might seem like quintessentially American enthusiasms. And while there is scant evidence of the same reactions elsewhere, *Snow White* nevertheless must be thought of not just as a domestic success, but as an international phenomenon. Like the other Hollywood studios, Disney made his films for a global market, and his short subjects had long been regarded in Europe, as in the United States, as significant works of art. One case study of the film's reception in Paris shows the international reach and importance of the Disney brand in general, and *Snow White* in particular.

Blanche-Neige et les sept nains stood out as a major cultural event in Paris when a dubbed version opened there, and then

elsewhere in France, in May 1938. The leading French film magazine *Pour Vous*, at the time a significant arbiter of cinematic culture in France, treated the movie as an important literary event, one that could only improve the lives of French children by taking on a role abandoned by parents. In its review of the film, *Pour Vous* lamented 'the number of today's parents who voluntarily leave their children in ignorance of fairy tales'. The review continued, 'the poor children … who don't have the joy of learning to read from the marvellous stories of Perrault, Anderson, the Brothers Grimm'. The producer of *Snow White* then took his place among these giants of children's literature: 'Thanks to Walt Disney for renewing the tradition of storytelling, for reinvigorating and perpetuating the fairy stories that have enchanted the imaginations of all people for centuries.' This was heady enough, but then the reviewer shifted from the literary to the aesthetic, declaring that 'certain scenes … designed by an elite group of artists … plunge the viewer into a kind of rapture [*ravissement*]'.[63]

Whether or not they felt rapturous, fans came in large numbers to see *Snow White* during its Paris engagement. The film opened at the Marignan-Pathé cinema on the Champs-Elysées, in the 8th *arrondissement*, one of the very ritziest neighbourhoods in the city. Established in 1933, this was one of Paris' grand movie palaces and the most important cinema of one of the largest motion-picture firms in the world, Pathé. By 1938, the cinema already had a history of premiering important films. Just before *Snow White*, the Marignan had shown the historical epic *La Tragédie impériale* about Rasputin and starring the popular French star Henri Baur, and the cinema typically showed the highest-quality films from France and Hollywood.

When *Snow White* first opened at the Marignan, the last show ran at 9:00 p.m. By its third week, the cinema had added a midnight show, not an extraordinary occurrence in Paris, with its mythically movie-crazy population, but certainly not the norm, either. And, of course, these midnight shows provide strong evidence that adults came to see the film in Paris as well as children, and that they took the film as seriously as they did any other major motion picture.

Attesting to its popularity, *Snow White* played at the Marignan for almost two months, when most first-run films in Paris appeared for just a week or two. Precise fan response remains difficult to determine, but some evidence, again from *Pour Vous*, indicates the special impact the film had on some viewers, and the possible importance of *Snow White* to Parisian film culture in general. The magazine published several letters about *Snow White*, apparently written by 'ordinary' fans. One of them echoed the review of the film, exclaiming, 'I could not describe the state of rapture which this little masterpiece plunged me into.' Another commented on the beautiful design of all of the dwarfs, 'each with his own character and habits', and then, somewhat oddly perhaps, but also showing the many ways the film could be enjoyed, commented on the 'sweet and caressing' eyes of the animated deer, likening them to the 'no less charming Loretta Young'. Yet another letter writer, this one from Nice, wrote simply, 'it's a marvel!'[64]

Paris at the time had about 200 cinemas. But film enthusiasts had also founded several important ciné-clubs, where major films might be seen again, obscure films viewed for the first time or the work of a major director looked at in detail. During the late 1930s, the Cercle de Cinéma was one of the most important clubs in the city, meeting usually once a week at an address on the Champs-Elysées just a few doors down from the Marignan-Pathé. While *Snow White* showed at the Marignan, the Cercle ran special evenings on 'Cinéma et érotisme' and on the films of Alberto Cavalcanti, showed King Vidor's 1929 all-black musical *Hallelujah!* and staged a retrospective on the work of the great Russian director Vsevolod Pudovkin. Towards the end of *Snow White*'s run at the Marignan, but as if to show the importance of Disney's film and also to contextualise it, and as evidence that the film evoked great interest among serious students of cinema, the Cercle staged what was almost certainly one of the first such retrospectives in Paris, and perhaps anywhere: an evening devoted to the 'History of the Animated Film'.[65] The programme has been lost to us, but one can only imagine that at least several Disney films had a prominent place in the evening's viewing and subsequent discussion.

5 Afterlife

Audiences in the UK showed just as much enthusiasm for *Snow White* as their counterparts in Paris. When, in the 1990s, film historian Annette Kuhn compiled data on celebrated films in Britain during the 1930s, *Snow White* emerged as the most popular American film of 1938. Moreover, when Kuhn asked a selection of movie fans, 'Do you recall any films that made a particularly strong impression on you?', Disney's film turned out to be one of twenty-two mentioned most prominently, in spite of (or perhaps because of) British censors ruling the film unsuitable for children under sixteen unless accompanied by an adult.[66] *Snow White* was the only animated film on the list, which also included such classics as *It Happened One Night*, *All Quiet on the Western Front* (1930), *The 39 Steps* (1935) and *Top Hat* (1935).[67] In keeping with others who work on movies and memory, Kuhn found that most people, even the most avid fans, typically remember the act of going to the movies, the smell of the popcorn, the friends who went with them, the décor of the cinema. Even just a few years later, they tend not to remember seeing specific films; that *Snow White* stands out as one of those films indicates the impact it made at the time and also the place the movie holds in popular memory.

This position in popular memory shows one aspect of what we might call the 'afterlife' of *Snow White*, its place in culture after that initial release across the United States and then internationally, between 1937 and 1939. Of course, just as he did with most of his feature-length cartoons, Disney reissued *Snow White* every few years, in cinemas, on video, on DVD as well as in other sites and on other technologies, so the film continually reaches new audiences, and can be viewed over and over again. But for more than seventy years, *Snow White* has inspired work in many areas: used by scholars in a

number of fields, employed by child welfare activists, cited (and ironised) by film-makers and television producers, it has generally functioned as a cultural touchstone for generations. To give just a sense of the significance of Disney's film, and of the manifold ways it has been cited in so many fields, we can take a look at just the first five to ten years or so of the cultural impact of *Snow White* following its initial release.

The cartoons

Like so many popular films, *Snow White* led to any number of imitations among Hollywood film-makers, and particularly, in this case, among animators. Indeed, of all the films that have been inspired by previous movies – think of the many mafia films that came from *The Godfather* (1972), or backstage musicals that derived from *42nd Street* – one of the greatest remains Warner Bros.' *Snow White* knock-off from 1943, *Coal Black and de Sebben Dwarfs*, directed by Robert Clampett. For years, Warner Bros. worked hard

Coal Black about to take a bite from the poison apple, in *Coal Black and de Sebben Dwarfs* (1943)

to differentiate their cartoons from Disney's rather than copy them (in the manner of Hugh Harman and Rudolf Ising's cartoons for MGM, which so often seemed like imitation *Silly Symphonies*). Thus, Porky Pig and Bugs Bunny seemed the antithesis of the increasingly sedate Mickey Mouse.

Coal Black invokes many of the images of *Snow White*, from the queen's castle to the heroine looking longingly into the well. But Clampett's cartoon inverts all of the racial characteristics of Disney's film, and even by extension the overwhelming whiteness of so much of Disney's oeuvre, beginning with the title and then the all-black 'cast'. *Coal Black* maintains the general outlines of the story, but changes the European-style, classically inspired music of *Snow White* into one of the great continuous jazz scores in movies. Carl Stalling, who arranged the music for the film, and Clampett have Coal Black singing 'Blues in the Night' from *Porgy and Bess* while also referencing other familiar jazz compositions, and they also include original music, sung not only by Coal Black but by the queen and a zoot-suited prince. Coal Black's own scanty, revealing outfit makes overt the more sublimated adolescent sexuality of *Snow White*, and places the film firmly in the present rather than an indistinct past, which is reinforced when the dwarfs are drafted into the World War II army.

At least Warner Bros. employed some African-American performers for the voices in the film: for instance, Vivian Dandridge, the sister of actress Dorothy Dandridge. Nevertheless, the film maintains many of the period's racial stereotypes – Hollywood's usual 'black' dialect as well as the exaggerated facial features of the characters. Thus, the film remains a complex and difficult one. But it is also a spectacular homage to, and reworking of, Disney's film; and at least one of the signs of the importance of *Snow White* is the calibre of the best imitations that it inspired.

Disney's dwarfs joined the war effort even before Warner Bros.' 'sebben dwarfs'. When the United States entered World War II, the Disney Studio converted most of its production to war-related

propaganda films and training shorts. Before that, however, Disney made films for the Allies, and in 1941 he produced *Seven Wise Dwarfs* for the National Film Board of Canada. The film provided information about the country's 'Five for Four' programme, through which Canadians could purchase a war certificate for C$4 that, in 1949, would be redeemable for C$5. *Seven Wise Dwarfs* opens with the scene from *Snow White* of the dwarfs singing the digging song as they look for diamonds in their mine. As they leave the mine, and the song shifts to 'Heigh-Ho', the voices and lyrics change, although the tune stays familiar, and we hear the following:

We're the wisest dwarfs we know ...
It's off to buy we go ...
We'll do our part with all our heart ...
We all must help you know ...
We'll win the war with 5 for 4.

Dopey buys Canadian war bonds in *Seven Wise Dwarfs* (1941)

In the first footage not from the original film, the dwarfs see a post office and go in to buy their certificates. Then the scene shifts incongruously to anti-aircraft artillery shooting down enemy planes, thanks to the dwarfs' contribution to the war effort.

Two years later, in 1943, the dwarfs shifted from the role of Allied propagandists to proponents of public health, albeit as part of an effort to secure the hearts and minds of non-combatants to the American cause. Under the auspices of the Office of the Coordinator of Inter-American Affairs, Disney made *The Winged Scourge* for distribution in Central and South America, as well as some less developed regions in the United States. A voiceover narrator describes a disease still rampant at the time, malaria, and the role of the mosquito in spreading it. Then, when he asks for 'six or seven people in the audience who will volunteer to help us combat this evil', the dwarfs appear ready for action. They go to work in a nightmare version of the forest in *Snow White*, this one full of pools of stagnant water and teeming with mosquitoes. Following the instructions of the narrator, and with 'Whistle While You Work' playing in the background, they clear the water of the weeds where the mosquitoes lay their eggs. The methods that follow are similarly effective, but dubious to modern sensibilities. The dwarfs spread oil on the water to suffocate the mosquito larvae, and then for good measure spray the water with the arsenic-based insecticide Paris Green.

So within a few years of *Snow White*, the dwarfs had emerged as quintessential good neighbours: to Canada in the north, helping in the Allies' war effort, and to the Latin American countries to the south, teaching them how to avoid disease. They are much changed, then, since *Snow White*, where the Princess must instruct them in the value of hygiene through regular baths, and where the entire setting seems removed from any of the world's geopolitical realities. These dwarfs now act as educators, and as the influence and impact of the film shift from animation to other areas, this pedagogical significance remains a constant.

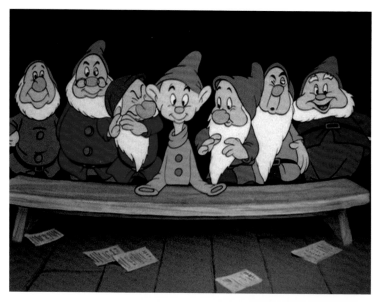

The dwarfs volunteer for action against mosquitoes, and then learn the value of pesticides in *The Winged Scourge* (1943)

Snow White and the lives of children

Within just a few years of its premiere, *Snow White* had begun to function as an important educational artifact in the classroom, and also among social scientists studying the psychological development of children. Educators and psychologists tested large numbers of children with some frequency during the period before World War II, with the Payne Fund Studies' exhaustive early 1930s findings on the effects of movies on pre-teenagers and adolescents perhaps the best known. This was also an era of great interest in the possibilities and difficulties of elementary and secondary school education, an interest spurred, on the left, by the growing number of progressive educators, influenced in particular by the pedagogical theories of John Dewey, and in general by the problems of dealing with the millions of students attending the nation's public schools.

Between 1939 and 1940, Florence Brumbaugh, from Hunter College in New York, conducted an extended experiment on the causes – and uses – of laughter in the classroom, hoping to understand the ways that humour might improve education. She polled a cross-section of New York City public school students to find out what made them laugh. Her findings underscored Disney's importance to children's lives at the time, and the film-maker's possible significance to the classroom. When children listed those stories that amused them the most, the two that tied for first place were Disney's first feature films, *Snow White* and *Pinocchio*, with *Mickey Mouse* films finishing third and *Donald Duck* fifth (Paramount's *Popeye* broke up the clean sweep of Disney cartoons).[68]

Indeed, educators took children's humour very seriously. At about the same time as Brumbaugh's study, the *Journal of Educational Research* published 'Children's Interests in Comic Strips' (1940), one of the more sedate and learned studies from the period that helped lead the way to Fredric Wertham's overheated 1954 condemnation of comics, *Seduction of the Innocent*.[69] The earlier study plausibly sought to understand the place of comics in kids' lives, and also establish some empirical data about what children

read and what they most liked. The findings for children, both white and African-American, revealed that the *Snow White* comics produced for newspapers by Disney ranked as the eighth most popular strip among boys and the preferred strip among girls. The researchers determined, perhaps not surprisingly, that boys enjoyed action-based comics (*Smiling Jack*, *Flash Gordon* and *Dick Tracy* were the three favourites), while girls favoured romance along with action. *Snow White* seemed to have elements of both, and the importance of the comic shows how that story had become ubiquitous in children's lives. They went to the movies to see *Snow White*, and *Snow White* also came to their homes, on the comics page of daily newspapers.

Snow White also performed more practical educational functions than helping experts divine the psychological development of the modern child. At least since the introduction of sound cinema, US-based educators had tried to figure out the place of the French or German or Italian film in the foreign-language classroom. By the early 1940s, it was a film from Hollywood that seemed the perfect fit for language instruction. Disney himself apparently provided a Spanish teacher in Southern California with the script for the Spanish version of *Snow White*, *Blancanieves y los siete enanos*. The class followed along in the script as they watched a screening of the Spanish version; indeed, 'the lilt of songs like "Off to Work We Go" [in Spanish] was inspiring'. But in a lament familiar to modern Disney scholars fearful of using any materials from the cartoons, this report on language instruction concluded that 'Unfortunately, copyright restrictions ... will thwart this procedure' for the foreseeable future.[70]

Snow White moved easily from public education to public welfare, but once again in the lives of children. By the mid-1940s, Disney's film signified the effectiveness of social systems to protect kids. In 1944, *The Social Service Review*, an academic journal devoted to issues of public policy, published an assessment of 'Child Welfare Services in Rural Tennessee'.[71] The programme in Tennessee

seemed to be the perfect blend of federal and state cooperation, and of public and private assistance. The case of ten-year-old Millie Daniel provided the best example. Her mother had already died and her father was dying. But Tennessee's network of foster homes took care of Millie, and a child welfare fund got her the medical care she needed, as well as a new wardrobe. Then, 'at Christmas, Millie made out her list, which consisted of *Snow White and the Seven Dwarfs*', and apparently referred to dolls from the movie, or perhaps a storybook, and 'a Mickey Mouse wrist watch', as well as other items. A local civic club 'provided these things and more' for Millie. A girl's desire for *Snow White* toys is the dream of innocent, underprivileged childhood. The state's capacity to provide them is the surest sign of the modern relationship of the government to the governed and of the commitment of public charity.

Shortly after its international release, in 1939, Disney's film came to symbolise a different kind of modernity, one marked by innocence on the one hand and global terror on the other. The prominent Brazilian journalist Emil Farhat wrote that children everywhere filled cinemas to watch 'ferocious encounters between Ali Baba and Popeye', and that 'Snow White speaks all the languages of the civilized world for all the children of the world'.[72] But as the counterpoint to that civilisation, and as a very different kind of modern experience, those same children hear 'from the heights of heaven the droning of a mighty airplane, with its sinister and powerful load'. They vacate the cinemas and rush with their mothers to 'the anti-airplane shelters'. In Spain and China, and elsewhere in the world, Disney's film and growing fascist movements represented two kinds of modernity; both of them highly technologised, both of them compelling people to gather in large public spaces – the cinema and the air-raid shelter. The similarities ended there. *Snow White* provided the possibilities of pleasure, diversion and hope. But now, for Farhat, 'everything that was gentle and tender in ... humanity ... breaks like a fragile dyke guarding the ocean of human wickedness'.

The lives of scholars

As we have seen, intellectuals like Farhat took *Snow White* seriously from the beginning. The film entered into academic discussions in a number of fields, often, just as with Farhat, as evidence of some of the complexities of modern life. For religious scholar Herbert Gordon May, writing in 1941 and looking for ways that 'literatures and traditions are constructed ... according to established patterns', *Snow White* was clearly the latest update of 'the story of Joseph's bloody coat', and he also traced elements of the tale through 'Sumerian, Babylonian, Horite, and Hebrew traditions'.[73]
Moving from religion to folklore, Clarese James, in 1945, viewed *Snow White* as the inheritor of numerous European traditions about deep-sleeping women, from Sleeping Beauty to Brunilde.[74] In the Evil Witch of *Snow White*, James saw one of the last 'traces of that period when matriarchate prevailed, and the wise woman ... handed down from mother to daughter knowledge of craft and medicines'.

These scholars saw the importance of Disney's film in its place in literary and cultural history, as the contemporary permutation of so much of western heritage. But there were others, in other fields, who believed the film marked something of a beginning rather than an end point. In 1940, Russian musicologist and composer Leonid Sabaneev published 'Opera and Cinema' in *The Musical Times*.[75] The piece lamented the apparent passing of opera, and 'the decay of an art which once, and not very long ago, occupied the leading place in the realm of music'. Sabaneev then cautiously endorsed the possibility of 'opera on the basis of the developed and transformed animated cartoon' as a means of saving that art, and then endorsed *Snow White* 'as the first attempt ... in the history of ordinary opera – the first attempt and the first stage'. Sabaneev explained that Disney's film was 'still not opera at all, but in it there are hints of the blending of the music with the cartoons'.

Sabaneev, then, the Russian intellectual and defender of the highbrow, viewed *Snow White* as did so many, from up and down the cultural hierarchy, from small-town exhibitors to big city movie

critics, from those who ran department stores to those in charge of museums, and from many in the film industry. For a few years, at least, before, during and just after World War II, *Snow White* indicated the possibilities for the future of cinema, for the continuation, in art for the masses, of religious and cultural traditions, and as the best hope, artistically and even socially, for children everywhere.

Conclusion

Snow White has lived on, as it were, to the present day. The periodic reissues of the film in various formats have usually been met with warm praise from critics and excitement from fans. When Disney opened Disneyland in the summer of 1955, a *Snow White* ride was among the original attractions, and there are still long lines for it today, while an automated Evil Queen periodically opens the window to scowl at the visitors passing by.

By the time Disneyland started attracting tourists from across the nation and around the world, *Snow White* probably no longer presaged, however, the most available and popular future of the animated film. The leaner, more mid-century modern style of United Productions of America (UPA) – think of Mr Magoo or Gerald McBoing-Boing – had become popular among fans and critics, and Disney himself had been instrumental in introducing and maintaining that style. Not only had some Disney defectors, like Shamus Culhane, gone over to UPA, but one of Disney's less acclaimed feature films, *Make Mine Music*, certainly looks less like *Snow White*, at least in some segments such as 'All the Cats Join In', and much more like the UPA films to come. And with a cartoon short like *Pigs Is Pigs* (1954), Disney showed his full embrace of that style, even while still making films that looked like *Snow White* and his other movies from the 1930s. Just a few years later, in 1961, Disney's *101 Dalmatians* would be a masterpiece of the modern style, with more angles and lines and less fully fleshed-out three-dimensionality.

Nevertheless, *Snow White* remains a cultural touchstone. Scholars in numerous fields still write about it, aesthetically, politically and otherwise. Two examples among many illustrate the reach of the film's scholarly influence. In 1997, film scholar Anne

Nesbet likened the aesthetics of the film's *mise en scène*, montage and characterisations to those in Sergei Eisenstein's *Ivan the Terrible*, from 1944 (and, indeed, the Russian director had been a longtime admirer of Disney). In 2005, for education specialist Dorothy Hurley, Snow White herself still had an impact on children seventy years after the film's premiere, affecting their self-image and especially their understanding of racial difference.[76]

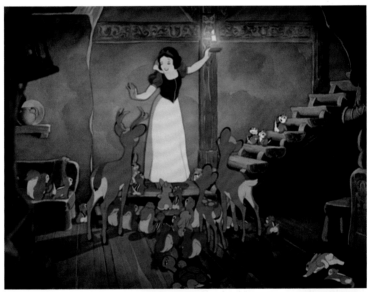

Cleaning the cottage in *Snow White* and the New York apartment in *Enchanted* (2007)

The effects of *Snow White* on popular culture remain the most ubiquitous, and probably the most memorable. The 1989 Oscar ceremony recorded one of the most lamentable *Snow White* references, when an actress portraying the Princess opened the show in a celebration of Hollywood's past – with appearances from such actors as Roy Rogers and Dale Evans, Buddy Rogers and Vincent Price – and then sang a duet with actor Rob Lowe, with new words set to the music from 'Proud Mary'. Needless to say, the effect was unsettling rather than ironic, and seemingly more of a misunderstanding of Disney's film than a homage to it.

Much more recently, though, the Disney Studio itself has got the reference right. Disney's 2007 production of the film *Enchanted* pays fitting tribute to *Snow White*, sending up the fairy-tale conventions of that movie but also remaining lovingly respectful of them. Amy Adams played the princess in *Enchanted*, and her uncanny ability to charm forest animals directly references Snow White's, while her rendition of the 'Happy Working Song' as she cleans a cockroach-infested New York apartment would be unthinkable without our memory of 'Whistle While You Work' and Snow White scrubbing the dwarfs' house.

Possibly the best sign, though, of the continuing impact of Disney's 1937 film is in the anecdotal evidence from generation after generation, of kids terrified by the Evil Queen, perhaps then as now the real star of the film, and the character who most directly links viewers from the late 1930s with those from the early twenty-first century.

Notes

1 *The Tuley Log* (Chicago, 1938), p. 61.
2 William Braswell, 'Thomas Wolfe Lectures and Takes a Holiday', *College English*, Vol. 1, No. 1, October 1939, pp. 11–22; *Snow White* on p. 18.
3 Maria Consuelo, 'La Parole est aux spectateurs', *Pour Vous*, No. 497, 25 May 1938, p. 12.
4 Orlie M. Clem, 'School News Digest', *The Clearing House*, Vol. 13, No. 9, May 1939, p. 576.
5 *Time*, Vol. 30, No. 26, 27 December 1937.
6 'Actors Mix with Cartoons', *Los Angeles Times*, 6 July 1924, p. B31.
7 Mordaunt Hall, 'The Screen', *New York Times*, 19 November 1928, p. 16.
8 'Original Music Scores Best', *Los Angeles Times*, 10 November 1929, p. I5.
9 'Aurons-nous bientôt nos Flip et nos Mickey?', *Pour Vous*, No. 127, 23 April 1931, p. 4.
10 For a good overview of the development and beliefs of post-World War I American avant-garde movements, see Juan A. Suárez, 'City Space, Technology, Popular Culture: The Modernism of Paul Strand and Charles Sheeler's *Manhatta*', *Journal of American Studies*, Vol. 36, No. 1, April 2002, pp. 85–106.
11 Margaret Farrand Thorp, *America at the Movies* (New Haven, CT: Yale University Press, 1939), p. 26.
12 Ibid., pp. 3–4.
13 'Recent Trends in the Arts', *Survey Graphic*, January 1933, pp. 37–42.
14 Richard deCordova, 'The Mickey in Macy's Window: Childhood, Consumerism, and Disney Animation', in Eric Smoodin (ed.), *Disney Discourse:*

Producing the Magic Kingdom (New York: Routledge, 1994), pp. 203–13. The period's assessment of Disney appears on p. 210.
15 James Thurber, 'The *Odyssey* of Disney', *The Nation*, 28 March 1934, p. 363.
16 'The Founding of the Film Library', *The Bulletin of the Museum of Modern Art*, Vol. 3, No. 2, November 1935, pp. 2–8.
17 'Should We Have Amusements on Sunday? Noted Theatrical People Discuss Question of Sabbath Entertainments', *New York Times*, 13 February 1910, p. SM3.
18 'Play for Children at Little Theatre', *New York Times*, 8 November 1912, p. 13.
19 'Castle Square-*Snow White*', *Boston Evening Transcript*, 19 December 1914, p. 24; 'To Give Play in Open Air Theatre: *Snow White and the Seven Dwarfs* Will Be Presented at W.M.I. This Evening', *The Day*, 21 July 1915, p. 4; 'Society Personals', *The Hartford Courant*, 9 April 1924, p. 15.
20 My sample of the comic strip comes from the *Meriden Record*, 1 March 1926, p. 7. Mordaunt Hall in *The New York Times* noted *Snow White and Rose Red* in his review of the *The Shepper-Newfounder*, 25 December 1930, p. 31.
21 'Hitler as Prince in Revised Fairy Tale Implants Kiss to Waken Sleeping Beauty', *New York Times*, 23 December 1934, p. E2.
22 Dorothy Ducas, 'The Father of *Snow White*', *Los Angeles Times*, 19 June 1938, Section I, p. 12. This syndicated article also appeared in many other newspapers.
23 In his biography, *The Animated Man: A Life of Walt Disney* (Berkeley:

University of California Press, 2007), Michael Barrier writes about the screening on pp. 101–2 and about Disney's war experiences on pp. 22–3.

24 'Three Little Pigs Persist', New York Times, 23 October 1933, p. 19; Mordaunt Hall, 'Another Language in Film Form', New York Times, 13 August 1933, p. X3.

25 Douglas W. Churchill, 'Now Mickey Mouse Enters Art's Temple', New York Times, 3 June 1934, p. SM12.

26 Edwin Schallert, 'Walt Disney Preparing to Start Production on His First Feature-Length Cartoon: Snow-White Legend to Be Made in Color', Los Angeles Times, 4 July 1934, p. 6.

27 Churchill, 'Mickey Mouse Enters Art's Temple'.

28 Ibid.

29 Patricia Zohn, 'Coloring the Kingdom', Vanity Fair, March 2010. Available online at <http://www.vanityfair.com/culture/features/2010/03/disney-animation-girls-201003>.

30 The Internet Movie Database (IMDb) has a useful biography of Caselotti. See <http://www.imdb.com/name/nm0143314/bio>.

31 'News of the Screen: Lily Pons Sought as Voice of Snow White in French', New York Times, 19 January 1938, p. 27.

32 Martin Krause and Linda Witkowski, Walt Disney's Snow White and the Seven Dwarfs: An Art in Its Making (New York: Hyperion, 1994).

33 'By the Way, Mr Disney—', New York Times, 1 December 1935, p. X9.

34 'Film Gossip of the Week', New York Times, 30 May 1937, p. 123; Philip K. Scheuer, 'Town Called Hollywood', Los Angeles Times, 17 October 1937, p. C4;

'News of the Screen', New York Times, 23 November 1937, p. 27.

35 'Squirming Disney Brows Go above Eyes of Dwarfs', Los Angeles Times, 17 October 1937, p. C4; 'Homemade Organ Stumps Hollywood Sound Men', Los Angeles Times, 14 November 1937, p. C4.

36 Edwin Schallert, 'Hollywood Pours Millions into Cartoon Films', Los Angeles Times, 21 March 1937, p. C1.

37 For a good discussion of the developments in colour, see Douglas W. Churchill, 'A Spring Showdown in Hollywood', New York Times, 19 April 1936, p. X3.

38 Edwin Schallert, 'Color Photography Will Lend Glamour to Astaire–Rogers Team', Los Angeles Times, 13 December 1937, p. A19.

39 'Disney to Make Bamby [sic] Next Year', New York Times, 22 June 1937, p. 26; 'News of the Screen', New York Times, 11 June 1937, p. 26.

40 'Disney to Make Bamby [sic] Next Year'.

41 See Robinson's advertisements in the Los Angeles Times, 6 December 1937, p. 13, and 9 December 1937, p. 13.

42 Dale Armstrong, 'Snow White's Debut Listed', Los Angeles Times, 21 December 1937, p. 6.

43 All articles in The Chillicothe Constitution-Tribune: 'Hats to Dwarf All Others, 29 January 1938, p. 4; Kroeger's advertisement, 3 February 1938, p. 5; 'Snow White and the Seven Dwarfs', 19 March 1938, p. 6.

44 Vladimir Propp, Morphology of the Folktale, translated by Laurence Scott (Bloomington: Indiana University Press, 1958).

45 Bruno Bettelheim, *The Uses of Enchantment: The Meaning and Importance of Fairy Tales* (New York: Vintage Books, 1975). See pp. 199–200 for this and subsequent citations.

46 For information on Moore, see Wikipedia: <http://en.wikipedia.org/wiki/Grace_Moore>.

47 An advertisement for the extravaganza appeared in *The New York Times*, 19 December 1937, p. 152.

48 Ducas, 'Father of Snow White'.

49 Richard Neupert, 'Painting a Plausible World: Disney's Color Prototypes', in Eric Smoodin (ed.), *Disney Discourse: Producing the Magic Kingdom* (New York: Routledge, 1994), p. 109. My comments in this section are indebted to Neupert's work, which is by far the best on colour in Disney's films.

50 An advertisement in the *Los Angeles Times* on 21 December 1937, p. 11, gave the prices and times for the film.

51 Edwin Schallert, '*Snow White* Achievement in Film Art', *Los Angeles Times*, 22 December 1937, p. 11.

52 The most accurate source for box-office receipts from the period can be found in the *Motion Picture Herald*. For *Snow White* in Los Angeles, for example, see 8 January 1938, p. 75; 22 January 1938, p. 57; and 29 January 1938, p. 72.

53 '*Snow White* Reaches Theatres in the Field, Setting New Records', *Motion Picture Herald*, 19 February 1938, p. 26.

54 'Results of the First Box Office Test of *Snow White and the Seven Dwarfs*', *Motion Picture Herald*, 12 February 1938, pp. 14–15.

55 'Round Table in Pictures', *Motion Picture Herald*, 29 January 1938, p. 82.

56 For the records and events surrounding the film, see '*Snow White* Reaches Theatres in the Field'.

57 Ibid.

58 'What the Picture Did for Me', *Motion Picture Herald*, 7 May 1938, p. 52; 21 May 1938, p. 52; 4 June 1938, p. 81.

59 Margaret Farrand Thorp discusses the single-film-only rental agreement in *America at the Movies*, p. 169.

60 'What the Picture Did for Me', 21 May 1938, p. 51; 4 June 1938, p. 81; 2 July 1938, p. 48.

61 Ibid., 4 June 1938, p. 81; 16 July 1938, p. 79.

62 'Home Office Aids', *Motion Picture Herald*, 12 February 1938, p. 73; 'Managers Round Table', *Motion Picture Herald*, 9 April 1938, p. 53.

63 J. G. Auriol, '*Blanche-Neige et les sept nains*', *Pour Vous*, No. 495, 11 May 1938, p. 7.

64 Consuelo, 'La Parole est aux spectateurs'.

65 For ciné-club listings, see *Pour Vous*, No. 494, 4 May 1938, p. 15; No. 495, 11 May 1938, p. 15; No. 499, 8 June 1938, p. 15; No. 500, 15 June 1938, p. 15.

66 Frederic M. Thrasher, 'Education Versus Censorship', *Journal of Educational Sociology*, Vol. 13, No. 5, January 1940, p. 293.

67 Annette Kuhn, *Dreaming of Fred and Ginger: Cinema and Cultural Memory* (New York: New York University Press, 2002), pp. 262–3.

68 Florence Brumbaugh, 'The Place of Humor in the Curriculum', *The Journal of*

Experimental Education, Vol. 8, No. 4, June 1940, pp. 403–9.

69 George E. Hill and M. Estelle Trent, 'Children's Interests in Comic Strips', *The Journal of Educational Research*, Vol. 34, No. 1, September 1940, pp. 30–6; Fredric Wertham, *Seduction of the Innocent* (New York: Rinehart and Company, 1954).

70 James B. Tharp, 'Foreign Language Instruction: General Review', *Review of Educational Research*, Vol. 13, No. 2, April 1943, pp. 115–26. The discussion of *Snow White* appears on p. 122.

71 Anne Sory, 'Child Welfare Services in Rural Tennessee', *The Social Service Review*, Vol. 18, No. 2, June 1944, pp. 224–43. Millie's case can be found on pp. 234–5.

72 Emil Farhat, 'Theirs Is the Kingdom of Heaven', *Books Abroad*, Vol. 13, No. 3, Summer 1939, pp. 315–16.

73 Herbert Gordon May, 'Pattern and Myth in the Old Testament', *The Journal of Religion*, Vol. 21, No. 2, July 1941, pp. 285–99. See p. 286 for the reference to *Snow White*.

74 Clarese A. James, 'Folklore and Fairy Tales', *Folklore*, Vol. 56, No. 4, December 1945, pp. 336–41. See p. 340 for the references to *Snow White*.

75 Leonid Sabaneev, 'Opera and Cinema', translated by S. W. Pring, *The Musical Times*, Vol. 81, No. 1163, January 1940, pp. 9–11. Sabaneev discusses the decline of opera on p. 9, and the place of *Snow White* in the future of opera on p. 10.

76 Anne Nesbet, 'Inanimations: *Snow White* and *Ivan the Terrible*', *Film Quarterly*, Vol. 50, No. 4, Summer 1997, pp. 20–31; Dorothy L. Hurley, 'Seeing White: Children of Color and the Disney Fairy Tale Princess', *The Journal of Negro Education*, Vol. 74, No. 3, Summer 2005, pp. 221–32.

Credits

**Snow White and the
Seven Dwarfs**
USA/1937
A Walt Disney Feature
Production
Walt Disney Productions,
Limited
Distributed by RKO Radio
Pictures Inc.
Photographed in
Technicolor
Recorded by Victor 'High
Fidelity' Sound System
Adapted from 'Grimms'
Fairy Tales' by Wilhelm
and Jacob Grimm

Supervising Director
David Hand
Sequence Directors
Perce Pearce
Larry Morey
William Cottrell
Wilfred Jackson
Ben Sharpsteen
Supervising Animators
Hamilton Luske
Vladimir Tytla
Fred Moore
Norman Ferguson
Story Adaptation
Ted Sears
Otto Englander
Earl Hurd
Dorothy Ann Blank
Richard Creedon
Dick Rickard
Merrill De Maris
Webb Smith
Character Designers
Albert Hurter
Joe Grant

Music
Frank Churchill
Leigh Harline
Paul Smith
Art Directors
Charles Philippi
Hugh Hennesy
Terrell Stapp
McLaren Stewart
Harold Miles
Tom Codrick
Gustaf Tenggren
Kenneth Anderson
Kendall O'Connor
Hazel Sewell
Backgrounds
Samuel Armstrong
Mique Nelson
Merle Cox
Claude Coats
Phil Dike
Ray Lockrem
Maurice Noble
Animators
Frank Thomas
Dick Lundy
Arthur Babbitt
Eric Larson
Milton Kahl
Robert Stokes
James Algar
Al Eugster
Cy Young
Joshua Meador
Ugo D'Orsi
George Rowley
Les Clark
Fred Spencer
Bill Roberts
Bernard Garbutt
Grim Natwick
Jack Campbell
Marvin Woodward

James Culhane
Stan Quackenbush
Ward Kimball
Woolie Reitherman
Robert Martsch

CAST (all uncredited)
Voice of Snow White
Adriana Caselotti
Voice of the Prince
Harry Stockwell
Voice of the Queen/Witch
Lucille La Verne
Voice of the Magic Mirror
Moroni Olsen
Voice of Sneezy
Billy Gilbert
Voice of Happy
Otis Harlan
Voice of Sleepy/Grumpy
Pinto Colvig
Voice of Doc
Roy Atwell
Voice of Bashful
Scotty Mattraw
Los Angeles Premiere
21 December 1937, at
Carthay Circle cinema
New York Premiere
13 January 1938, at Radio
City Music Hall
General US Release
4 February 1938
London Premiere
24 February 1938, at New
Gallery cinema
Paris Premiere
6 May 1938, at Marignan-
Pathé cinema
MPPDA no. 3870
Aspect ratio: 1.33:1
Running time:
83 minutes

Bibliography

Armstrong, Dale, '*Snow White*'s Debut Listed', *Los Angeles Times*, 21 December 1937, p. 6.

Auriol, J. G., '*Blanche-Neige et les sept nains*', *Pour Vous*, No. 495, 11 May 1938, p. 7.

Barrier, Michael, *The Animated Man: A Life of Walt Disney* (Berkeley: University of California Press, 2007).

Bettelheim, Bruno, *The Uses of Enchantment: The Meaning and Importance of Fairy Tales* (New York: Vintage Books, 1975).

Braswell, William, 'Thomas Wolfe Lectures and Takes a Holiday', *College English*, Vol. 1, No. 1, October 1939, pp. 11–22.

Brumbaugh, Florence, 'The Place of Humor in the Curriculum', *The Journal of Experimental Education*, Vol. 8, No. 4, June 1940, pp. 403–9.

Churchill, Douglas W., 'Now Mickey Mouse Enters Art's Temple', *New York Times*, 3 June 1934, p. SM12.

——, 'A Spring Showdown in Hollywood', *New York Times*, 19 April 1936, p. X3.

Clem, Orlie M., 'School News Digest', *The Clearing House*, Vol. 13, No. 9, May 1939, p. 576.

Consuelo, Maria, 'La Parole est aux spectateurs', *Pour Vous*, No. 497, 25 May 1938, p. 12.

DeCordova, Richard, 'The Mickey in Macy's Window: Childhood, Consumerism, and Disney Animation', in Eric Smoodin (ed.), *Disney Discourse: Producing the Magic Kingdom* (New York: Routledge, 1994).

Ducas, Dorothy, 'The Father of *Snow White*', *Los Angeles Times*, 19 June 1938, Section I, pp. 7, 12.

Farhat, Emil, 'Theirs Is the Kingdom of Heaven', *Books Abroad*, Vol. 13, No. 3, Summer 1939, pp. 315–16.

Hall, Mordaunt, 'The Screen', *New York Times*, 19 November 1928, p. 16.

——, '*Another Language* in Film Form', *New York Times*, 13 August 1933, p. X3.

Hill, George E. and M. Estelle Trent, 'Children's Interests in Comic Strips', *The Journal of Educational Research*, Vol. 34, No. 1, September 1940, pp. 30–6.

Hurley, Dorothy L., 'Seeing White: Children of Color and the Disney Fairy Tale Princess', *The Journal of Negro Education*, Vol. 74, No. 3, Summer 2005, pp. 221–32.

James, Clarese A., 'Folklore and Fairy Tales', *Folklore*, Vol. 56, No. 4, December 1945, pp. 336–41.

Krause, Martin and Linda Witkowski, *Walt Disney's Snow White and the Seven Dwarfs: An Art in Its Making* (New York: Hyperion, 1994).

Kuhn, Annette, *Dreaming of Fred and Ginger: Cinema and Cultural Memory* (New York: New York University Press, 2002).

May, Herbert Gordon, 'Pattern and Myth in the Old Testament', *The Journal of Religion*, Vol. 21, No. 3, July 1941, pp. 285–99.

Nesbet, Anne, 'Inanimations: *Snow White* and *Ivan the Terrible*', *Film Quarterly*, Vol. 50, No. 4, Summer 1997, pp. 20–31.

Neupert, Richard, 'Painting a Plausible World: Disney's Color Prototypes', in

Eric Smoodin (ed.), *Disney Discourse: Producing the Magic Kingdom* (New York: Routledge, 1994), pp. 106–17.

Propp, Vladimir, *Morphology of the Folktale*, translated by Laurence Scott (Bloomington: Indiana University Press, 1958).

Sabaneev, Leonid, 'Opera and Cinema', translated by S. W. Pring, *The Musical Times*, Vol. 81, No. 1163, January 1940, pp. 9–11.

Schallert, Edwin, 'Hollywood Pours Millions into Cartoon Films', *Los Angeles Times*, 21 March 1937, p. C1.

——, 'Color Photography Will Lend Glamour to Astaire–Rogers Team', *Los Angeles Times*, 13 December 1937, p. A19.

——, '*Snow White* Achievement in Film Art', *Los Angeles Times*, 22 December 1937, p. 11.

Scheuer, Philip K., 'Town Called Hollywood', *Los Angeles Times*, 17 October 1937, p. C4.

Smoodin, Eric (ed.), *Disney Discourse: Producing the Magic Kingdom* (New York: Routledge, 1994).

Sory, Anne, 'Child Welfare Services in Rural Tennessee', *The Social Service Review*, Vol. 18, No. 2, June 1944, pp. 224–43.

Suárez, Juan A., 'City Space, Technology, Popular Culture: The Modernism of Paul Strand and Charles Sheeler's *Manhatta*', *Journal of American Studies*, Vol. 36, No. 1, April 2002, pp. 85–106.

Tharp, James B., 'Foreign Language Instruction: General Review', *Review of Educational Research*, Vol. 13, No. 2, April 1943, pp. 115–26.

Thorp, Margaret Farrand, *America at the Movies* (New Haven, CT: Yale University Press, 1939).

Thrasher, Frederic M., 'Education Versus Censorship', *Journal of Educational Sociology*, Vol. 13, No. 5, January 1940, pp. 285–306.

Thurber, James, 'The *Odyssey* of Disney', *The Nation*, 28 March 1934, p. 363.

Wertham, Fredric, *Seduction of the Innocent* (New York: Rinehart and Company, 1954).

Zohn, Patricia, 'Coloring the Kingdom', *Vanity Fair*, March 2010. Available online at <http://www.vanityfair.com/culture/features/2010/03/disney-animation-girls-201003>.

General newspaper articles

'Actors Mix with Cartoons', *Los Angeles Times*, 6 July 1924, p. B31.

'Aurons-nous bientôt nos Flip et nos Mickey?', *Pour Vous*, No. 127, 23 April 1931, p. 4.

'By the Way, Mr Disney—', *New York Times*, 1 December 1935, p. X9.

'Castle Square-*Snow White*', *Boston Evening Transcript*, 19 December 1914, p. 24. 'Disney to Make *Bamby* Next Year', *New York Times*, 22 June 1937, p. 26.

'Film Gossip of the Week', *New York Times*, 30 May 1937, p. 123.

'The Founding of the Film Library', *The Bulletin of the Museum of Modern Art*, Vol. 3, No. 2, November 1935, pp. 2–8.

'Hitler as Prince in Revised Fairy Tale Implants Kiss to Waken Sleeping Beauty', *New York Times*, 23 December 1934, p. E2.

'Home Office Aids', *Motion Picture Herald*, 12 February 1938, p. 73.

'Homemade Organ Stumps Hollywood Sound Men', *Los Angeles Times*, 14 November 1937, p. C4.

'Managers Round Table', *Motion Picture Herald*, 9 April 1938, p. 53.

'News of the Screen: Lily Pons Sought as Voice of Snow White in French', *New York Times*, 19 January 1938, p. 27.

'News of the Screen: Sidney Harmon Signs Producing Contract with Paramount – Selznick–Metro Deal Is Pending', *New York Times*, 23 November 1937, p. 27.

'Original Music Scores Best', *Los Angeles Times*, 10 November 1929, p. I5.

'La Parole est aux spectateurs', *Pour Vous*, No. 497, 25 May 1938, p. 12.

'Play for Children at Little Theatre', *New York Times*, 8 November 1912, p. 13.

'Results of the First Box Office Test of *Snow White and the Seven Dwarfs*', *Motion Picture Herald*, 12 February 1938, pp. 14–15.

'Round Table in Pictures', *Motion Picture Herald*, 29 January 1938, p. 82.

'Should We Have Amusements on Sunday? Noted Theatrical People Discuss Question of Sabbath Entertainments', *New York Times*, 13 February 1910, p. SM3.

'*Snow White* Reaches Theatres in the Field, Setting New Records', *Motion Picture Herald*, 19 February 1938, p. 26.

'Society Personals', *The Hartford Courant*, 9 April 1924, p. 15.

'Squirming Disney Brows Go above Eyes of Dwarfs', *Los Angeles Times*, 17 October 1937, p. C4.

'*Three Little Pigs* Persist', *New York Times*, 23 October 1933, p. 19.

'To Give Play in Open Air Theatre: *Snow White and the Seven Dwarfs* Will Be Presented at W.M.I. This Evening', *The Day*, 21 July 1915, p. 4.